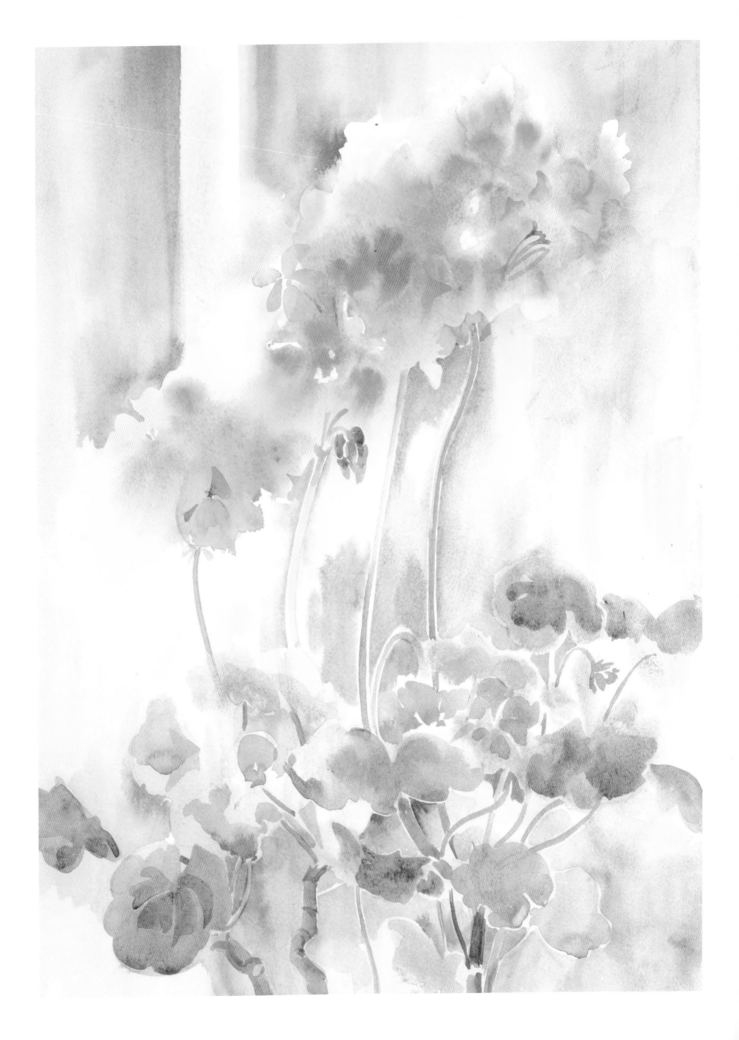

JILL BAYS

watercolours
in a weekend
FLOWERS

pick up a brush and paint your first picture this weekend

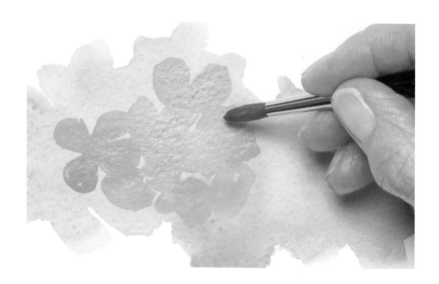

David & Charles

A DAVID & CHARLES BOOK

First published in the UK in 2004
Copyright © Jill Bays 2004
Hardback reprinted 2004

Distributed in North America
by F&W Publications, Inc.
4700 East Galbraith Road
Cincinnati, OH 45236
1-800-289-0963

A catalogue record for this book is available from the British Library.

ISBN 0 7153 1636 2 hardback
ISBN 0 7153 1637 0 paperback (USA only)

Printed in China by SNP Leefung Printers
for David & Charles
Brunel House Newton Abbot Devon

Senior Editor Freya Dangerfield
Art Editor Sue Cleave
Project Editor Ian Kearey
Production Controller Kelly Smith

Visit our website at www.davidandcharles.co.uk

David & Charles books are available from all good bookshops; alternatively
you can contact our Orderline on (0)1626 334555 or write to us at FREEPOST EX2110,
David & Charles Direct, Newton Abbot, TQ12 4ZZ (no stamp required UK mainland).

contents

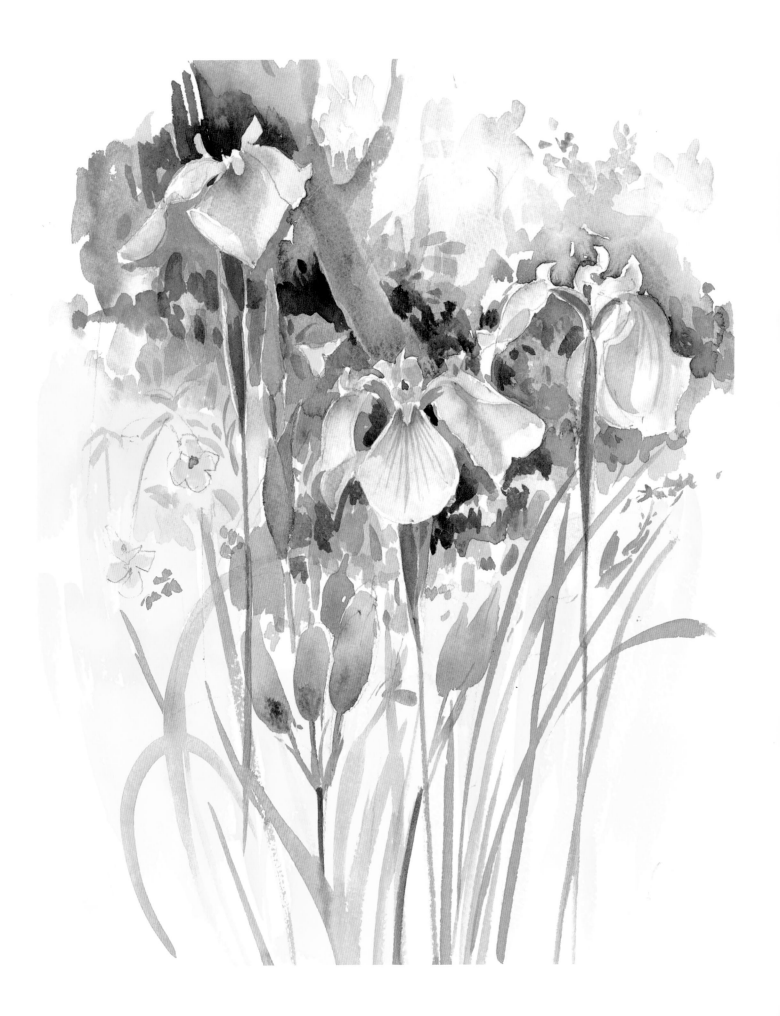

introduction

Flowers fascinate us – the scents, the mystery of the shapes and the variety, spanning the seasons of the year. Sometimes, when we see a flower for the first time, we are so overcome by its beauty that it seems imperative to put it down on paper, to record the feelings and emotions we had on first seeing it – but flowers don't wait: they sway and turn, blossom and fade, so you have to record your impressions swiftly or wait for the next bloom to appear.

why watercolour?

Watercolour is an ideal medium for painting flowers: the paint is transparent, just right for delicate petals, the colours can be gentle or bright, and the brush is good for echoing both sweeping curves and upright stems. The more you paint, the more you will learn about using your brush to create shapes that evoke leaves and petals, which paper and which methods suit your style of painting, how to mix colours to give the correct tint or tone, and how you can enhance your paintings with the right backgrounds.

how to use this book

In the first part, all the equipment you need to make watercolour paintings is explained, along with how to stretch and prepare paper and choose a basic palette of colours. There is also advice on how to mix colours, which leads into the fundamentals of laying washes, the two basic painting styles – working wet into wet and wet on dry – as well as interesting methods of creating textures, how to identify common flower shapes, and how to compose your paintings.

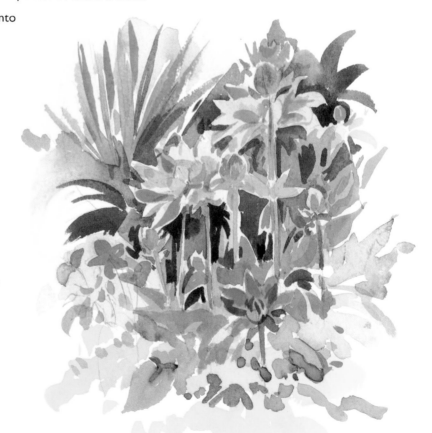

The second part is where the practical work begins, with suggestions for achieving a finished painting in a weekend. Each step-by-step project is divided into Saturday exercises, which focus on a theme and technique to build up your repertoire and confidence. The Sunday paintings develop these exercises into full-scale painting projects, with suggested palettes of colour and choice of brushes and equipment, so you can follow the steps to create your own work.

materials

For the beginner, there is a bewildering array of art materials to choose from, so this first section is intended to guide you towards making the right choices for you. The basic equipment of paper, paints and brushes is discussed, with particular relevance to the projects and exercises found later in the book, as well as guidance on forming a simple palette of colours from which you can work. There are also a number of accessories or auxiliary pieces of equipment which can prove useful. It is all too easy to be seduced into buying things you will probably never use, so start sparingly – as you become more experienced and begin to experiment more, you will be able to make your own decisions about the materials you like, and which work best for you.

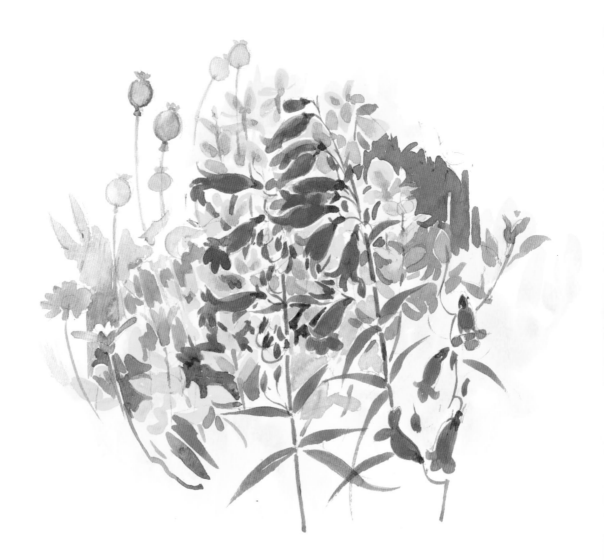

your workspace

When painting in watercolours you can paint more or less anywhere you like, as your equipment is light and can be transported easily. Of course, a bright and airy studio is ideal, with good lighting and space to set up a still life – however, this may not be possible, but try to find a working environment that has a fair amount of natural light from a window or roof window.

working positions

Some artists like to work standing at an easel, while others prefer to sit at a table – this is often dictated by the choice of subject. Having your drawing board set at a slight angle and being able to move your hand freely are both desirable; as a student I used two chairs – one to sit on and the other to rest my board on, with my palette held in one hand and a water pot readily available.

easels

Easels are useful for working outdoors, as they enable you to see above any vegetation between you and your subject, whereas you may be swamped when sitting down. Table easels are good value, but you could just as easily support your drawing board on a thick book.

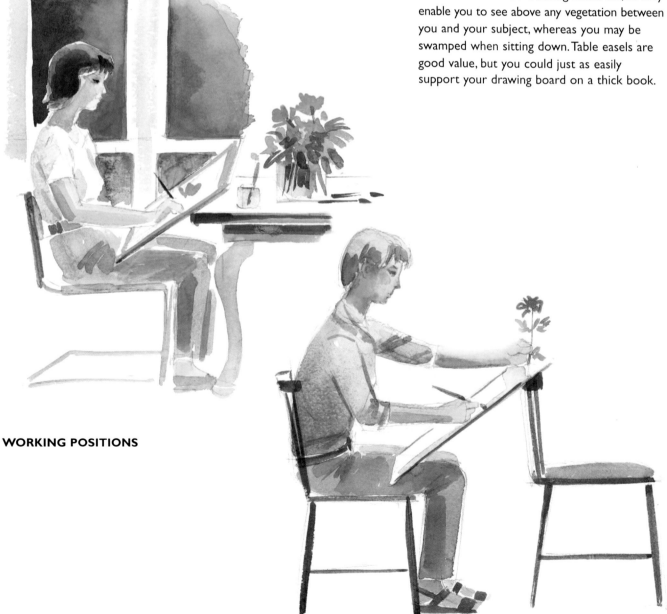

WORKING POSITIONS

paper

Paper, in all its variations, is a fascinating subject, and there are many more types than you would imagine at first glance, from tissue paper, so thin and yet so tough, through to thick and speckled recycled paper. We are all familiar with cartridge (drawing) paper, originally used for wrapping cartridges, and sugar paper, which was used for wrapping foodstuffs, both of which can be used effectively for making art. Paper can be glossy or matt, and thick or thin.

what type of paper?

As watercolourists, we need a paper that is thick enough to take one or more washes; for sketchbook work, cartridge paper can be drawn on and can take the odd wash of paint, although it is not designed to take too much water. You can buy sketchbooks of watercolour paper, which are more suitable but more expensive.

Both watercolour and cartridge paper can be bought as pads or single sheets; the latter are cheaper and can be cut to size. You can also buy paper in the form of blocks, which are stuck together on all four sides and have a substantial base; these are ideal for painting away from home, as you don't need to stretch the paper beforehand (see opposite). To remove a sheet from the block, simply slip a knife around all the edges and lift the sheet away.

It is well worth taking time to get to know different papers and their attributes; art shops usually stock sample sheets and 'pochettes' – manufacturers' packs of a range of papers you can try before you decide. Whatever you choose, be generous when buying paper – people starting out often cramp their style by buying small pads because they are unsure of themselves and unwilling to work freely and boldly.

TYPES OF PAPER
These sketches show the effects of paint on Hot-pressed (top left), NOT (centre left and above right) and Rough (left) papers.

watercolour paper

There are three basic surfaces of watercolour paper, each with its own name:
- Hot-pressed, or HP is smooth and suitable for more detailed work.
- Cold-pressed, also called CP or NOT (not Hot-pressed), has a slight tooth – the tiny peaks and hollows in the surface – and is ideal for general-purpose painting.
- Rough paper has a more pronounced tooth, and is suitable for broad work, such as landscapes.

Watercolour paper is available in different weights; I find the thicker the better, but the lightweight papers can always be stretched. To avoid cockling (where the paper shrinks and buckles when washes are applied) it's best to use a paper of 300gsm (140lb) or heavier. For most of the exercises and projects in this book, I used Bockingford 300gsm (140lb) NOT, which is available everywhere and is reasonably priced; in addition, it is not too difficult to wash out mistakes, and the surface is softer than that of more expensive papers, making it relatively easy to use.

Watercolour paper varies in its 'whiteness' – some papers are very white, others more creamy, so check before you make a purchase. You can also buy tinted watercolour paper in blue, grey or cream; if you want to work on darker paper, you may have to make a move to pastel papers.

stretching paper

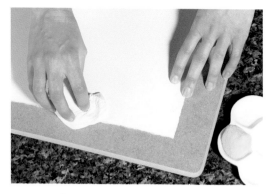

step 1

Start by wetting the paper. You can either soak it in the bath for a few minutes, then shake off the surplus water before positioning it on your board, or you can place the dry paper on the board and wet it all over with a sponge or damp cloth.

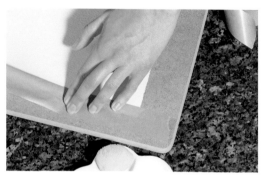

step 2

To stick the damp paper down you must use gummed paper strip, not masking tape or sticky tape. Cut the strip into four lengths 12mm (½in) longer than each side of the paper. Wet each length with a sponge or damp cloth and stick it down, overlapping the ends. Start with the two longer sides.

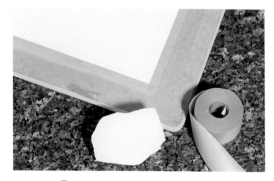

step 3

Finish with the two shorter sides, then leave the paper to dry naturally. You can place it near a radiator to speed up the drying, but don't use a hairdryer, as it can cause the gummed strip to tear away from the paper.

TIP

• When the paper is dry after being stretched you will have a flat, taut surface to work on. Only remove the paper from the board when you are sure you have finished the painting and it has dried thoroughly. •

materials

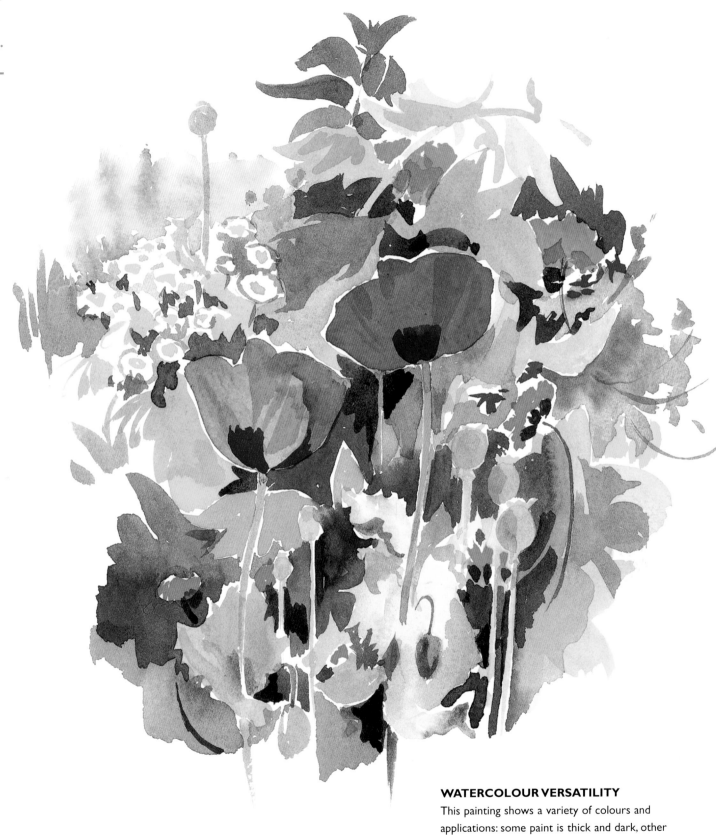

WATERCOLOUR VERSATILITY

This painting shows a variety of colours and applications: some paint is thick and dark, other washes are light and pale; some colours are used as a light tint; some are painted straight onto the paper, while others are painted over one another.

paints

Paint itself is possibly the most confusing part about watercolours – one look at a catalogue or the selection available in a shop is at the same time tempting and alarming: where do you start? The simple answer is to begin slowly, with just a few colours, and to build up your own palette of colours gradually and as you need them.

types of paint

Watercolour paint is basically made from pigment, water, gum and glycerine. Some artists make their own paints, but the vast majority buy and use ready-mixed paints, which are available in either tube or pan form. Tube paint is semi-liquid and can be used neat (although it is most often diluted), while pans are dry and require the addition of water before you can paint. You can buy ready-made selections of pan colours, but a good way to start is to get an empty pan case and fill it with your own selection of colours; this way you won't waste space with colours you may never use or which are unsuitable.

You do not have to stick exclusively to either tubes or pans – if you find that a mixture of these works best for you, go ahead and use it.

The price of each colour varies, depending on the cost of the pigment, and paints are sold in artists' or students' grades; although artists' paints are more expensive, I find it is best to use these from the start, as the paint flows more smoothly and the colours are purer.

The basic palette used in this book is covered on pages 34–35, but you need the three basic primary colours to start with – I suggest cadmium red, cadmium yellow and ultramarine – plus yellow ochre and burnt sienna as extras.

qualities of paint

No two colours are the same when it comes to how they behave on the paper: some are transparent, some more opaque; some are pretty well permanent, meaning they do not fade when exposed to sunlight over time, and others are fugitive, meaning they need to be protected from light if they are to keep their intensity of colour; some can be washed off the paper without leaving much of a mark, while others stain the paper and are thus impossible to remove. Manufacturers have different methods of grading each of these qualities, but most people find these out for themselves as they go along.

TIP

● *When using pans, run a brush loaded with clean water over them before starting, as this helps to soften the paints and make them run more smoothly.* ●

WATERCOLOUR TUBE PAINTS

brushes

Getting used to working with a brush is essential if you want to be a watercolourist – it is your most important tool. The first thing to remember is that if you can draw with a pencil, you can draw with a brush.

Look in any art store or catalogue, and you'll see an overwhelming number of brushes to choose from – but I mainly use no more than three: from smallest to largest a No. 4 or No. 6, a No. 8, and a No. 12. The No. 12 is my favourite and will do almost anything, as it is firm and flexible, holds plenty of water and has a good point; I suggest you start with this size, even if it seems to be quite large when you begin.

The best material for watercolour brushes is sable, but this is expensive; there are many good synthetic substitutes and sable/synthetic blends. When buying brushes, checking the point is vital, as you should be able to use the point as well as the body of the bristles. I use the smaller sizes for very fine details, but be warned – using very small sizes can hinder your progress if you want to achieve fresh, clean and clear watercolours. So take courage and work with the large brush almost exclusively at first, and reserve the smaller sizes for later.

Practise making as many sorts of strokes as you can, from long, flowing marks to short, dabbing ones – the time spent doing this is invaluable. Draw with your brushes, and try to become as used to working with a brush as you are with a pencil.

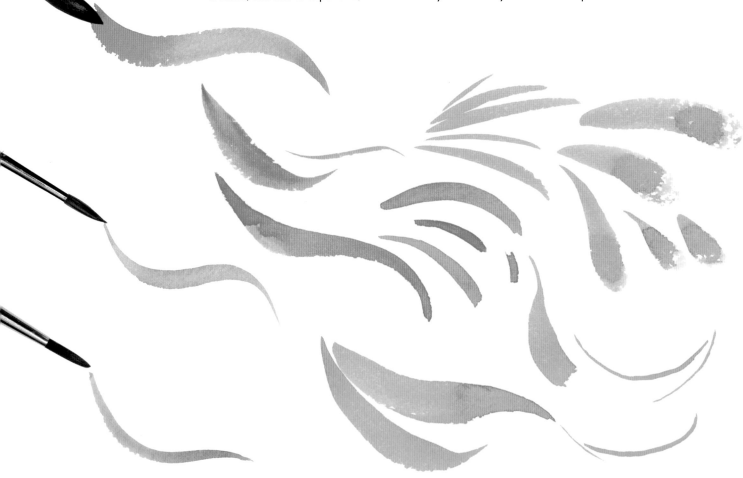

**BRUSHES:
NOS. 12, 8 AND 4 ROUND**

VERSATILE BRUSHES

These brushstrokes show the different kinds of strokes you can achieve with just one brush, the No. 12 – in addition to using it for laying all kinds of washes.

other equipment

Paper, brushes and paints are obviously the three most important tools of watercolour painting, but there are other pieces of equipment, some essential, that are useful to save time or to achieve certain effects.

drawing board

It is important to have the right drawing board for the task. I have several boards of various sizes, but my main board is a lightweight rigid wooden board measuring a generous 380 x 510mm (15 x 20in). Hardware stores will usually cut board to the size you want. Hardboard is a useful alternative, but it can warp if you stretch paper on it.

palettes and boxes

Some form of clean, white palette is essential. There are many styles and shapes available, but an old white plate is excellent as a starter palette for tubes. Squeeze each colour around the outside, and use the centre for mixing.

Again, there are different kinds of watercolour box. As mentioned on page 11, it is best to buy an empty box and make up your own colour selection of pans. You can also use the lid of a box for mixing tube colours.

accessories

The following list reflects the basics required for the exercises and projects in this book.

- Two water pots – jam jars will do, but plastic ones won't break.
- Grades B and 2B pencils are best for sketching and preliminary drawing.
- A soft eraser.
- A ruler for measuring and judging angles.
- Masking fluid – a rubber solution that acts as a resist to help maintain the white of the paper when required.
- A natural sponge for dampening paper; the flow is better than that from artificial sponges.
- Kitchen paper or clean cloths or rags for blotting off paint or mopping up spills.
- A hairdryer is useful for drying washes quickly, but is not essential.

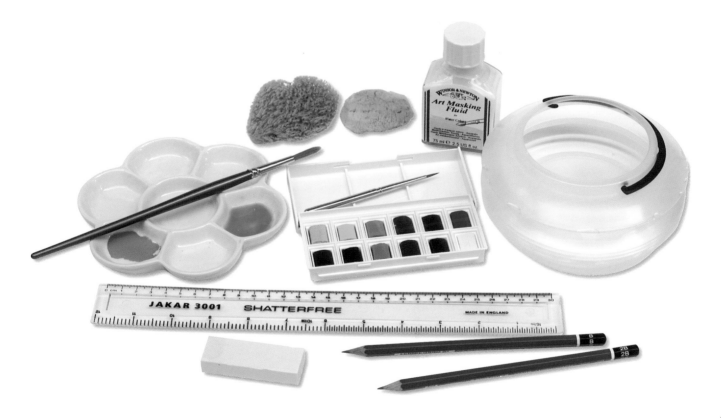

working outdoors

If you are like me, a great deal of your outdoor sketching is likely to take place in your own garden or a garden that you know well, so that you become very familiar with its situations and viewpoints and thus have plenty of time to think about the subjects you want to paint. Away from such familiar places, you have to choose more rapidly.

Outdoor sketching is great fun – you have to gamble on the weather and be prepared for anything. Travel light and cut down on equipment (see page 111), but always take something to sit on, a hat and sun cream as well as your painting equipment. Go with the right attitude, be prepared to make lots of thumbnail sketches, and don't worry if you don't complete anything in situ.

Enjoy yourself!

THE AUTHOR IN HER GARDEN

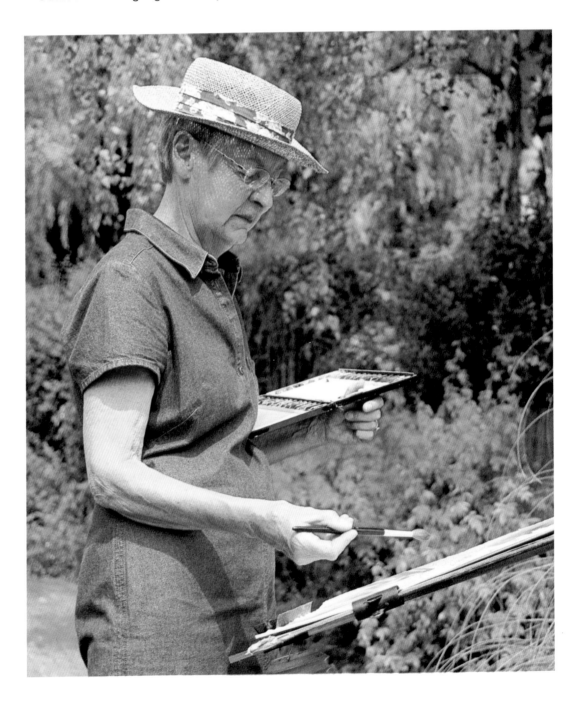

sketchbooks

A sketchbook is an essential part of your equipment – use it for ideas, sketches, even painting. It is your source book, so carry it everywhere and make sure it is readily to hand; some artists use their sketchbooks as a kind of diary, and draw in them every day. Whatever you choose, use it!

types of sketchbook

There are many different sizes of sketchbook. I find an A4 cartridge paper one very useful for most purposes, and also have ones containing heavier weights of watercolour papers, which are very useful for taking on holidays. Smaller books are excellent as they can be slipped into a pocket or bag and used in crowded places.

There is also a choice of bindings: the two most popular are spiral bound or a pad with soft or even hard covers. You could also make your own sketchbooks with your favourite papers, which will then become very personal records.

GARDEN IN JUNE
Coloured pencils are useful when you can't, or don't want to, carry too much equipment – but don't forget to take some water when using watersoluble crayons or pencils.

PLANT STUDY
This sketch was made in a watercolour sketchbook, which is useful for both pencil and watercolour work. I combined the two for this detail of *Iris foetidissima*, with its decorative seed pods.

techniques

Now you know the basic range of equipment, it's time to draw a deep breath and get started. The first thing to do is to experiment: try out the brushes, paints and papers; mix the paints with water and see what lovely effects you can achieve. The following techniques are designed to take you through the process of painting flowers, from the most simple shapes to putting a group of flowers in context. Start with a simple pencil drawing of the general shapes, lay your washes working from light to dark to build up the colour, and always plan ahead if you need to include white in your painting. Keep your colours fresh by using clean water and washing your brushes frequently, and keep your paper flat and clean. The most important factor is your own observation – spend time looking at flowers; as you train yourself to become more observant, your knowledge of flowers and plants will increase and your paintings will improve.

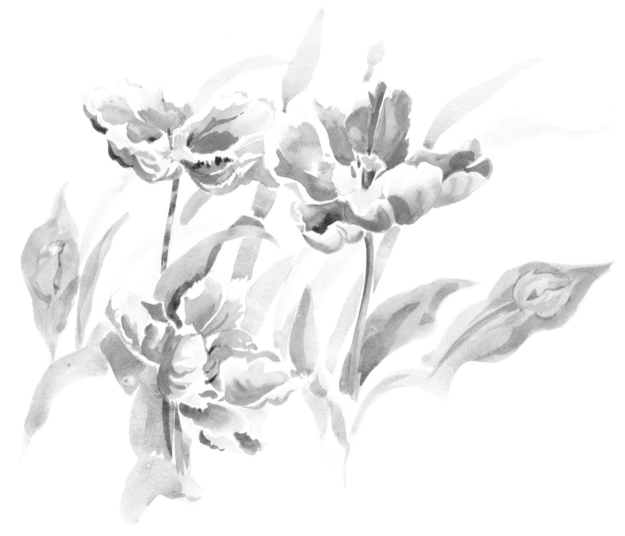

flower structures

Knowing the basic structure of a flower or plant, although not absolutely necessary for most purposes, will help you get to know its character – whether it has five or six leaves, whether the leaves are alternate or opposing, and their shape.

There are many different types of plants, from annuals to perennials, shrubs and trees. Each has a common name and a family name as well as a genus, which covers a group of closely related plants. The painting of a tulip here shows the principal parts of a flower: the petals, stamens and pistil, and anther, stem and leaves.

As an artist it is vital for you to know the basic shape of the flower you intend to paint – even if you do not know its name, being able to identify its simplified shape and characteristics will help you enormously when you come to draw or paint it. The following pages illustrate the most common shapes.

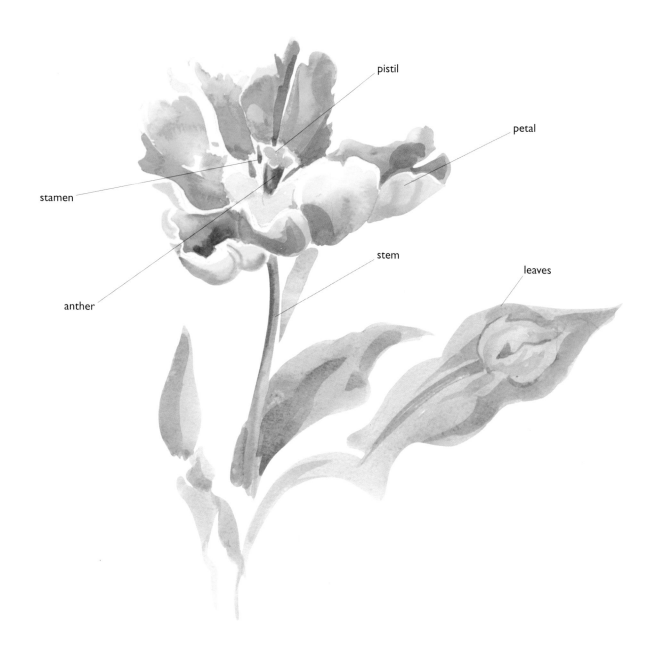

pistil

petal

stamen

stem

leaves

anther

drawing flower shapes

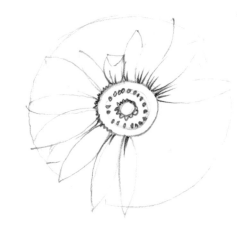

When drawing and painting flowers it helps to realize that the stamens and pistil, shown on the previous pages, are the reproductive parts, the calyx and sepals determine the angle of the flower – some flowers, like daisies, are upright, and some, like foxgloves, hang their heads – and the petals are part of the whole structure and, of course, add to the individuality of the plant through variations in size, colour and shape.

Drawing flower and leaf shapes becomes an easy task if you break the shapes down into cups and bowls, circles, ellipses and trumpets. When drawing daisy-like flowers, practise drawing ellipses from all angles; some daisies are bowl-shaped and some cup-shaped, and it can be difficult to separate them. Once you have learned to draw all the shapes from every angle, then you can add the characteristics of the individual flower.

Some flowers, such as hippeastrum, are trumpet-shaped; lilies are cone-shaped; there are many pea-like flowers, and others have lips; dahlias and chrysanthemums are pompon-shaped; gladioli grow in spikes or plumes; some grow singly, others in groups. There are many flowers that I haven't mentioned here, but as you become more practiced in observation and proficient in drawing, you will be able to recognize and set down the many and varied shapes for yourself.

ELLIPSES

Daisy shapes are rarely flat – some tend to be bowl-shaped. The ellipse – a circle seen in perspective – will give you a guide to work from. Again, practise looking and drawing from every angle.

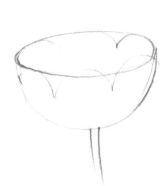

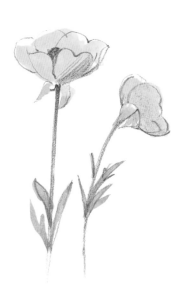

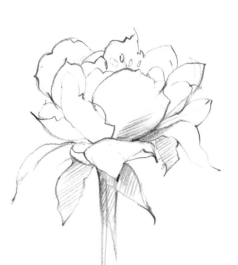

CUPS AND BOWLS

The cup-or bowl-shaped flower is represented here by a buttercup, one of the simplest shapes. The tree peony (right) is also cup-shaped, even though it has more petals which can obscure the shape. Start by drawing the cup from all angles, and add the petals later.

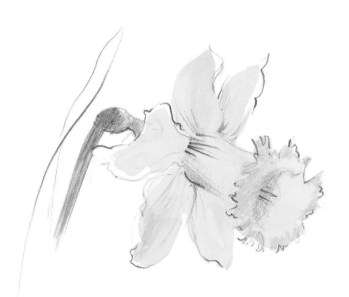

TRUMPETS

Trumpet shapes, such as the daffodil and lily, can be constructed from a tube that flares out at the end. On closer inspection, the daffodil actually consists of two shapes, an ellipse and a trumpet.

RAYS AND POMPONS

These shapes can be more complex. The ray of a sunflower could also be a disc, while a kerria, like some dahlias or chrysanthemums, is multipetalled and could be constructed from a series of circles.

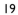

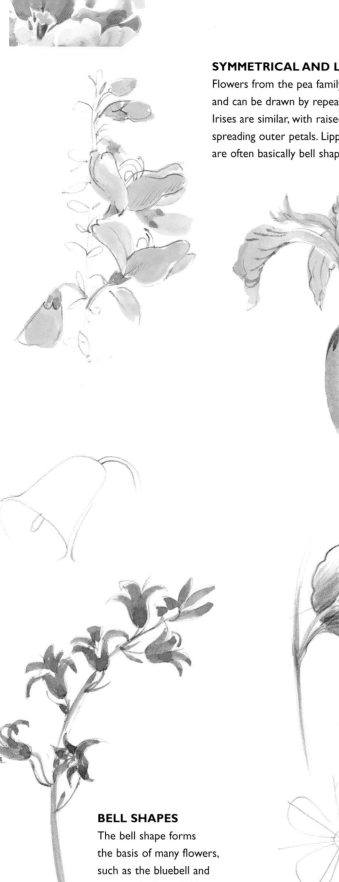

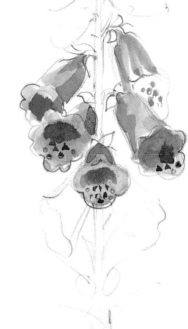

SYMMETRICAL AND LIPPED

Flowers from the pea family are naturally symmetrical and can be drawn by repeating one side on the other. Irises are similar, with raised inner petals (standards) and spreading outer petals. Lipped flowers, such as foxgloves, are often basically bell shapes with the addition of a lip.

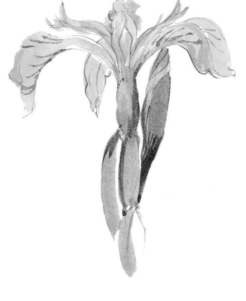

BELL SHAPES

The bell shape forms the basis of many flowers, such as the bluebell and campanula. Some bell-shaped flowers, such as the rhododendron, grow in groups.

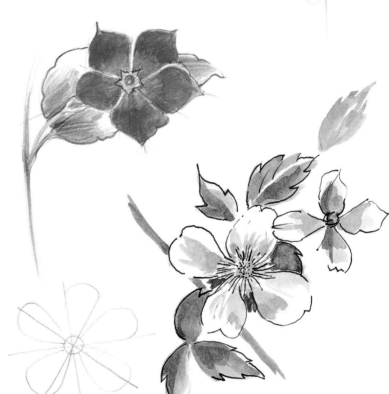

STAR SHAPES

Periwinkles and clematis are both star-shaped. If you position the flower facing you, it can be drawn by starting in the centre, with lines radiating outwards to start the petals.

PLUMES AND SPIKES

There are a number of flowers that grow in plumed or spiky shapes, such as this gladiolus, but have individual flowers within the overall shape.

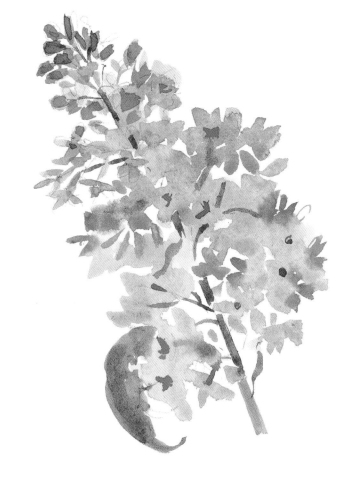

MULTIHEADS

Multiheaded flowers, such as hydrangeas and lilacs, are made up of small florets which could be any of the shapes shown on these pages. In this case, always look for the whole shape and avoid trying to paint each individual flower.

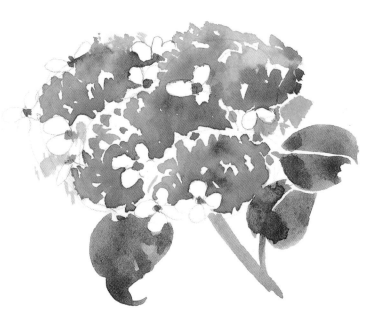

drawing leaves and stems

When drawing or painting leaves, look for their character: are they glossy and dark or soft and pale? Are they single or in groups, variegated or plain? The edges can be serrated or smooth, while some leaves, like the iris, are sword-shaped. Leaves of grass can be described with swift, sure strokes of the brush, but leaves that twist and curl are like ribbons – practise and let the brush do the work for you!

Try to keep to light, medium and dark shades and introduce blues and reds to amend the colours if necessary. Make a chart of all the greens you use so you can instantly recognize which particular shade you need.

SEED PODS

Seed pods of all kinds can be used to make useful and interesting additions to paintings. I collect them in autumn, and can then use them in a painting all the year round.

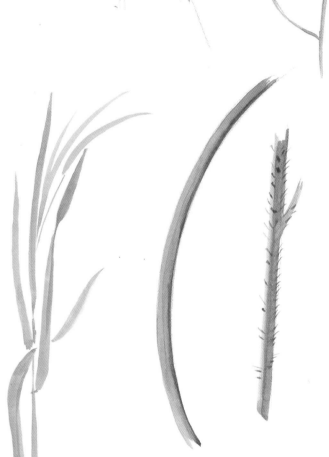

CROPS AND GRASSES

Oats, wheat, barley and grasses of all kinds can help to create interest and variety in a painting. Practise drawing the fine lines with brushes that have a good point, whatever the size.

STEMS

Although they all have to support a flower and leaves, stems vary enormously – some are strong and thick, others slender, and some, like the poppy, are hairy. You don't need to put in every detail, but note the dark and light sides, and try to use a single, firm brushstroke.

SHINY LEAVES

In order to paint the shine that appears on certain leaves, such as those of camellias or holly, paint an initial light blue-grey wash and allow it to dry before you apply the green; this should create an effective shine.

CURVES

If you find it difficult to draw curving shapes successfully, practise with a pencil to get the basic idea; but in may instances, a brush is the ideal tool to use, so persevere.

BACKS AND FRONTS

Leaves which present both sides to the observer, like this variegated leaf, need to be drawn and painted carefully. Look closely, and draw what you see.

LEAVES WITH VEINS

The ivy leaf shown here has only been half painted – the first wash of light green represents the veins. The negative shapes of the darker green define the pattern of the veins and is only applied after the first wash has dried.

LEAVES AND STEMS

No matter how well you draw the leaves and stem, they must join together accurately, or the effect is ruined. Note that two greens are used here.

PATTERN

This painting of leaves shows how nature creates patterns in the arrangements of how the leaves grow – they may be two-coloured or variegated, and they may overlap; geranium and cyclamen have their own distinctive patterns on each individual leaf. I use the brush to indicate the shapes of the leaves; by varying the pressure you can make the shapes with a few strokes.

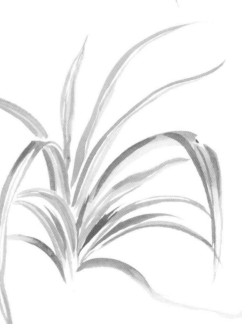

brushstrokes

It's now time to get down to work and practise using the brush to draw flowers and leaves. Ideally you should work from a flower and some leaves in front of you; or follow the examples below. Either way, try to work life-size, the same size as the flower itself, and don't worry if you make a mistake or a blot, just concentrate on getting the shape in one go. Use a No. 12 brush except where specified. For inspiration, look at the leaves on trees and imagine how you could represent each of the types, from pine needles and the narrow leaves of a willow to apple or oak leaves – each would require a different kind of mark.

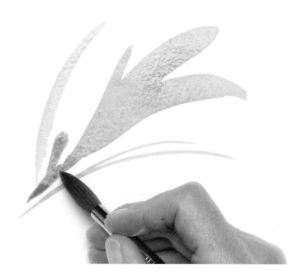

Starting with the tip of the brush at the base of the flower, make swinging strokes with your hand and wrist. Press harder where you want the shape to be fuller. Switch colours and use the same technique for leaves.

Alternate between brushes as you practise painting leaves – here, I used a No. 4 round to create very thin leaves, using the same method of a single brushstroke for each leaf.

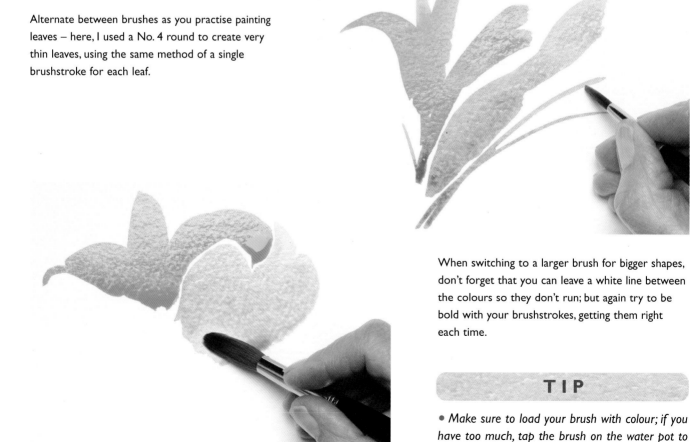

When switching to a larger brush for bigger shapes, don't forget that you can leave a white line between the colours so they don't run; but again try to be bold with your brushstrokes, getting them right each time.

TIP

• Make sure to load your brush with colour; if you have too much, tap the brush on the water pot to release the paint. •

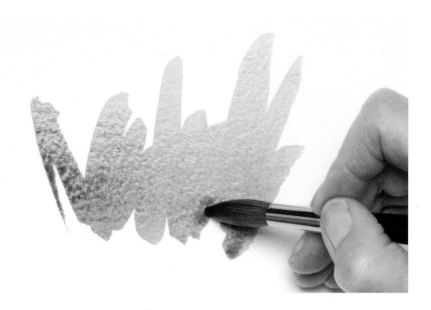

To give the appearance of a mass of grassy leaves, you may need to blend together different single short strokes. Try not to hesitate, and resist the temptation to touch up the results, as you will soon learn to gauge the right amounts of water and paint for your purposes. If it doesn't work, start again.

Here, I am putting a second wash over a dry one. Note the hold of the brush, which is loose and quite unlike the standard pencil grip, and which helps when making short, dabbing strokes like this.

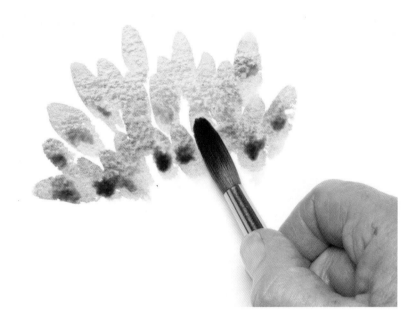

Here, I am using a small No. 4 brush to make fine, grass-like lines. Again there should be no stopping and starting, but continuous sweeps of the brush that make a fine, taut line.

flat washes

A wash is basically any layer of colour on the paper, large or small, applied with a brush or sometimes a sponge. All watercolour paintings are made up of a number of washes, either laid side-by-side or applied in overlapping layers. The two washes most used are flat washes, where the paint is laid down in as even a colour as possible, and graduated washes (see page 28), where deliberate variations on the flat colour are created. All watercolours dry about 50 per cent lighter than when applied, so take this into account when mixing a wash.

Painting even a simple wash of colour needs a certain amount of thought and preparation, and there are several basic things you should do before you put brush to paper. Chief among these, always mix plenty of colour, more than you think you will need, and have a large container for water. I often use an old saucer for mixing a large wash, to make sure I have enough. Test the colour on scrap paper.

Set the drawing board at a slight angle, as gravity will help the wash to flow, but not so much that you lose control of the wash when it is applied, and make sure the large, No. 12 brush is fully loaded.

Starting from the top, apply an even stroke across the paper, then repeat this a little lower so that the top of the new stroke joins on to the bottom of the top one. Continue down the paper in this way, and don't be tempted to go back and touch up the wash in any way. Allow the wash to dry.

damping

Another way to lay a flat wash is to dampen the paper first with clean water and a natural sponge. You can apply the water to both large and small areas, but it is best to stretch the paper first or use a heavyweight paper, to prevent cockling.

Lightly dampen the area with clean water. Then load a No. 12 brush with plenty of wash and apply as described above, working quickly with smooth strokes of the brush. The paint should go on easily and dry really flat and even. Be aware that the wash will dry lighter than when painting onto dry paper.

laying a wash around a shape

Painting around a shape is easy as long as you keep your wash really wet and work quickly. You need to practise to build up confidence – masking fluid can be used to block in the shape (see pages 60–61), but you should try to work without it. To help the wash go on evenly, you can dampen the area around the shape, going into any corners with a clean brush.

see pages 60–61

TIP

• If you need to increase the flow of a wash, you can move the drawing board, tipping it this way and that to help the wash move on the paper. •

Draw the shape, then start by working fully across the paper. When you paint into the shape, try to work with even strokes, and don't get sidetracked into putting in details. Work quickly with lots of water in the mix.

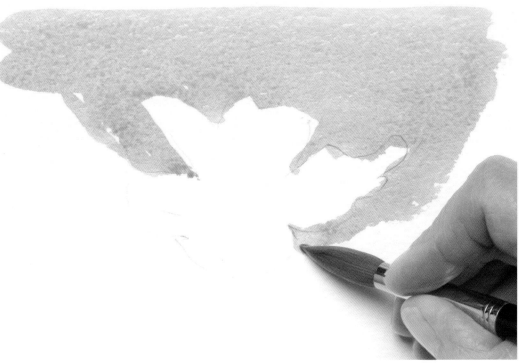

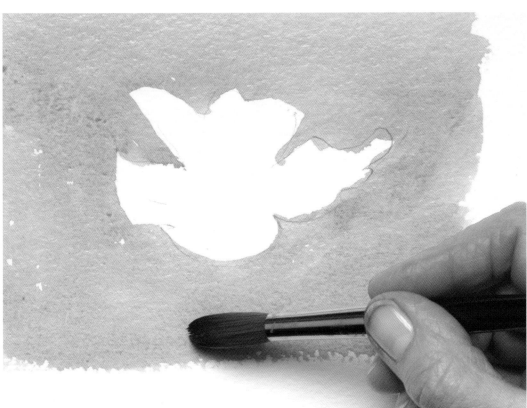

Once the shape has been made, finish by applying even strokes across the lower part of the paper, as you did at the top.

graduated washes

Painting a graduated wash, one that gets lighter as you progress down the paper, is a matter of adding clean water to the layers of the original wash colour, using a similar technique as for a flat wash. You can also use different colours in a graduated wash, which is particularly useful for painting flowers and leaves where a smooth transition of colours is needed. The main thing to bear in mind is that you must use plenty of loose, fluid colours if you want to achieve a good result.

Mix up plenty of colour and start as for a flat wash. As you work down the paper with even strokes, add a little clean water to the brush; work quickly, so that the paint has no chance of drying on the paper between the strokes.

For a more dramatic graduation, start with a standard-strength wash, then add more and more water to the brush with each succeeding stroke until you are painting with almost clear water.

For a colour-graduated wash, instead of adding clean water, apply a different colour; practice and experience will enable you to make a smooth blend and transition between the colours. The blob in the bottom right is where I attempted to touch up the yellow wash – do as I say, not as I do!

You can achieve some amazing graduations by dropping a fluid colour from the brush onto a half-dry wash; the smoothest graduations can be made when the first wash is still shiny wet but not fluid. Here, the colour runs have made cauliflower-like shapes in the wash.

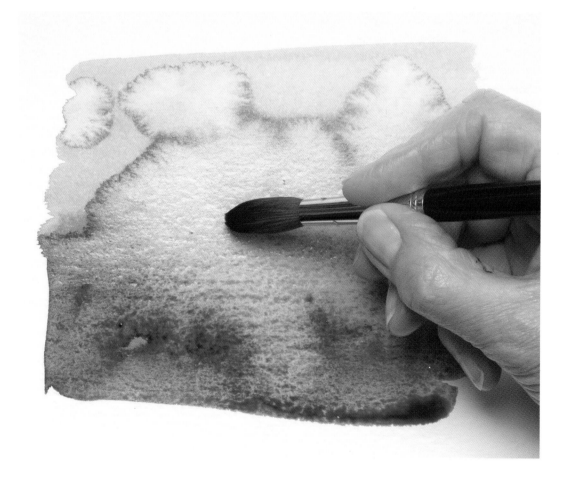

wet-into-wet and wet-on-dry washes

Once you have learned how to apply single layers of washes, you have the choice of working wet into wet or wet on dry. The former technique is what makes watercolours unique, as the results are unpredictable at the best of times.

It is fun to experiment with applying wet colours onto other wet ones: some colours react against each other, pushing the paint away, and others mix gently to give soft effects. Certain colours, such as ultramarine and burnt sienna, separate when they are mixed and create a granular texture on the paper.

The unpredictability of working wet into wet is all part of the watercolour process – mistakes, runs and blotches can sometimes be incorporated into a painting, and keeping one eye open for such happy accidents keeps you on your toes.

Working wet on dry is more straightforward, as long as you remember to work in layers from the lightest colours to the darkest ones. Always let each wash dry completely before you paint over it, or you will find that the new wash picks up the underneath colour and runs and bleeds, making the edges indistinct and fuzzy.

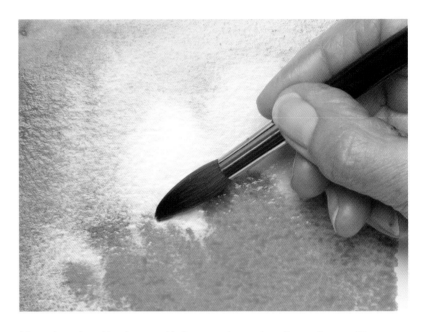

Here, the colour blends smoothly because the wash underneath was still wet when the new colour was applied. I used a paper towel to blot off paint for the lighter areas.

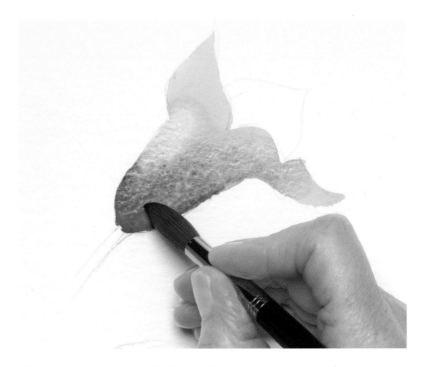

Wet-into-wet blending is useful for creating shadow colours on a flower. Allowing the colours to mix on the paper makes a more vibrant colour than mixing on the palette.

TIP

• If you use a hairdryer to speed up the drying process, allow the wash to dry naturally so you don't push wet paint around on the paper and create runs and unwanted effects. •

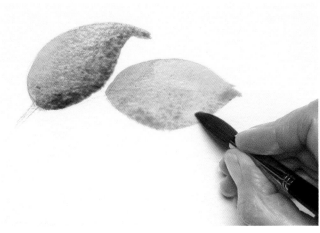

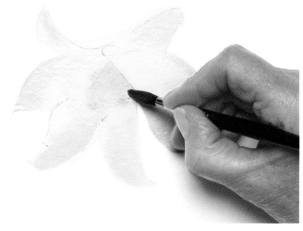

These light green leaves were overpainted with a darker green and a touch of red-brown while still wet. You have to work quite quickly to achieve this successfully.

In this variation on wet on wet, the petal shape was initially painted with clean water; the pink was just touched in on the petal tips, and ran into the water. When this had dried completely, the green centre was painted in the same way.

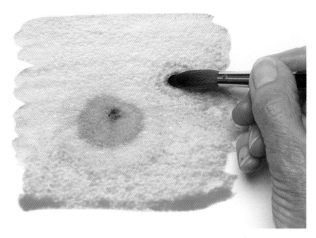

Prussian blue dropped into a wet alizarin crimson wash reacts strongly, with the blue pushing the pink away. You could use this effect as a basis for creating flower shapes.

Other colours seem more sympathetic to each other. Here, soft washes of ultramarine and brown madder combine gently to make a warm grey.

The red flower and green stem were painted on a completely dry yellow wash – wet on dry – giving sharp edges to the colours. The first wash must dry thoroughly: this could take an hour or so, depending on the room temperature, unless you use a hairdryer to dry the first wash.

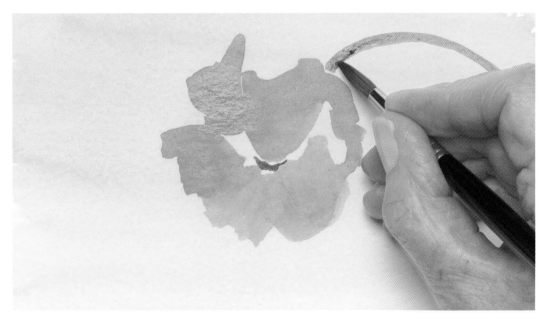

working with colour

How inviting a paintbox is: you immediately want to dip your brush in and try all the colours. But what makes that lovely pinky red or that soft green? Colour is a very subjective subject, and you often know instinctively what is right for you and what colour combinations you like to use – but this needs to be combined with a little basic colour theory for a fuller understanding.

Practically every colour that you will use is arranged in the colour wheel. It is based on the three primary colours – red, yellow and blue – and the colours you can mix from them: the secondary colours – orange, green and violet – and the tertiary colours, where the primaries and secondaries are blended in varying proportions. Secondary colours, also known as contrasting or complementary colours, make for pleasant combinations when used together – red with green, blue with orange and yellow with violet.

Some colours are described as 'warm', for instance red, and some as 'cool', such as blue, reflecting the emotions they arouse in the viewer. But there can be differences in some colours, with yellows, greys and greens, among others, having a wide spectrum from warm to cool. Experiment to see how you can make warm or cool greys from the different reds and blues in your palette.

When you pick up a colour from the paintbox, or squeeze it directly from the tube, and use it without diluting with water, it is called saturated colour. When you add water it becomes a tint, so within each colour there is a full, almost infinite range from light to dark.

Note that it is difficult to mix a true purple from red and blue, so for flower painting it is best to buy violet; in the same way, permanent rose is a useful colour to use for some of the pinks found in flowers.

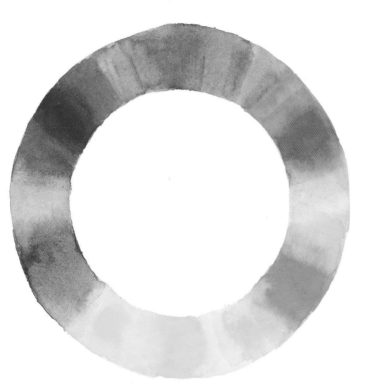

COLOUR WHEEL

This version of the colour wheel is based on the main colours that I use; you would probably get different secondary colours by blending different paint versions of reds, yellows and blues. I have put the saturated colours in the middle of each colour and the hues spreading out on both sides.

SATURATED COLOUR

The darkest version of ultramarine, on the left of the bar, is the saturated colour, with no water used to dilute it. You can see how gradually diluting the pure colour changes the tint and makes it lighter.

NEUTRAL COLOURS

These subdued greens, browns and greys are made by mixing different combinations of primary and secondary colours. When experimenting with colours, it is a good idea to make notes of how you achieved ones that you find useful.

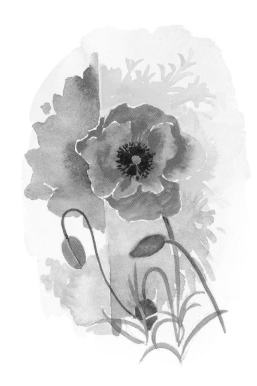

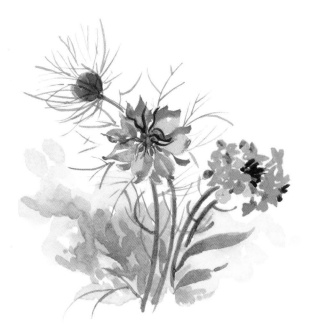

PRIMARY COLOURS

I used only primary colours in this little painting of a poppy – cadmium red, cadmium yellow and ultramarine – and they combine to make a harmonious and colourful composition.

SECONDARY COLOURS

Here, love-in-a-mist (*Nigella*) is paired with an orange wallflower. Cobalt blue is one of the cooler blues, a primary which combines well with the warm cadmium orange, a secondary colour between red and yellow on the colour wheel.

WARM AND COOL

A purple cornflower (made by mixing Winsor violet and ultramarine) is paired here with wild flowers, ox-eye daisy and charlock. The warmth of the purple and the background contrasts well with the cool Winsor yellow used for the charlock.

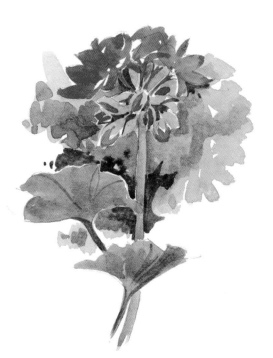

RED AND GREEN

The primary red and its complementary colour green always work well together, and are one of nature's success stories – think of the red and green of poinsettia, or the rich and cheerful combination of red holly berries with dark green leaves. The geranium here is painted with magenta, while the green is a mixture of sap green and burnt sienna.

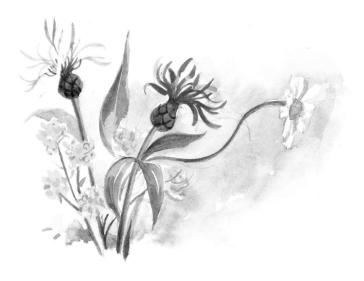

basic palettes

ultramarine

cadmium red

magenta

yellow ochre

burnt sienna

cadmium yellow

olive green

Despite the temptation of using as many colours in your paintbox as you can, it is vital to develop a basic palette of colours for your subject; you can always add to it when necessary. One of the main reasons for having just a few basic colours is that doing so means that with practice you will become adept at mixing and thus understanding how colours combine and work together, both in nature and on paper.

My basic palette, which I have used for the step-by-step Sunday paintings and most of the other works in this book, consists of ultramarine, cadmium red, magenta, yellow ochre, burnt sienna, cadmium yellow and a green which is mixed from cadmium yellow and ultramarine. Of course there are many other useful colours, but I suggest you make a colour chart for yourself, carefully using the basic palette to become familiar with the colours and the many hues that can be achieved through different combinations and concentrations. Generally, in painting, it is the tonal values of a colour that are important – the relationships of each colour to its neighbour – and the local colour, the actual colour of an object, less so.

Although watercolour is a transparent medium, some colours are more transparent than others, and some are more opaque, such as the cadmium yellow on this page. Gouache paint, also known as body colour, is an opaque watercolour; white gouache is useful, as it can be mixed with watercolour and can be used pure to make flashes of white in a painting, useful for speckles on petals or leaves.

colour symbolism

Throughout the ages colour has been associated with situations, memories and feelings. Our moods are symbolized by colours: red for passion, blue for serenity, white for purity and black for death. Study paintings to see how artists have used colour to arouse emotions in the viewer, and see how you can do the same in your work.

mood and atmosphere

You can use the temperature of colours to set the mood and atmosphere of a painting. The most obvious way is to associate each colour with the times of day, from early morning to late evening or even night; but you can also use the seasons in the same manner – for instance, spring is associated with fresh, bright, coolish colours and summer with warmer versions of the same greens and yellows, while autumnal reds and browns tend to warm, and winter has cool blues and greys.

In each of the illustrations opposite, I laid a light background wash to suggest the mood, let it dry completely and then painted the flowers wet on dry. Colour roughs such as these are very useful: they help you plan the mood of a painting, they can give an idea of composition, they are fairly quick to do, and can be changed easily if they are unsatisfactory.

using watercolour mediums

● *There are a number of additives and mediums that are sold to add to watercolours. These are specifically designed to give different properties and effects to the paint; the two best-known and most used are gum arabic, which helps to give body to the paint and aids painting details, and ox gall, a few drops of which added to a wash will help the flow of the paint as you apply it to the paper.* ●

COLOUR ROUGHS

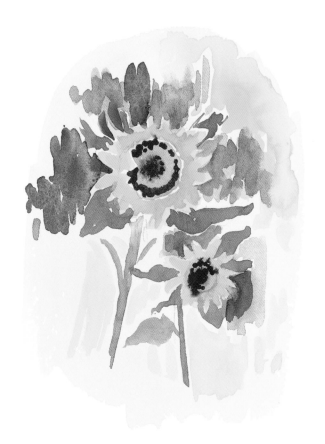

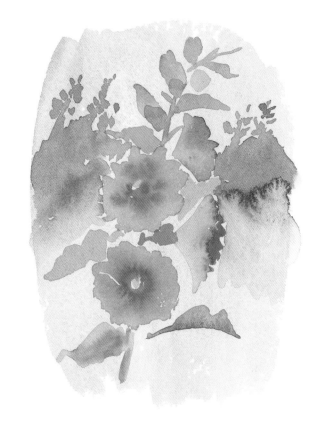

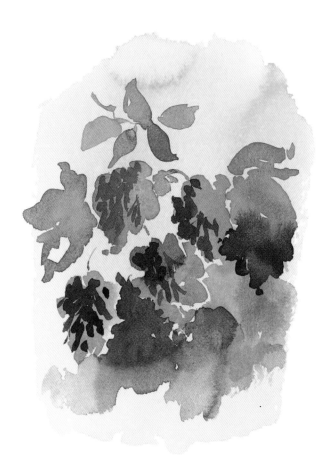

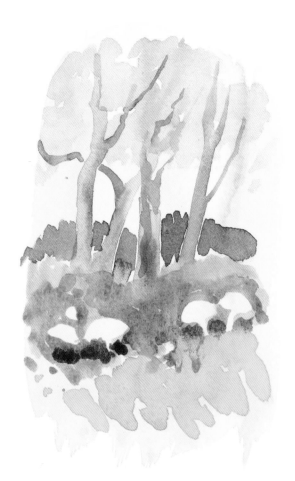

mixing colours

We can use paint in various ways – neat, mixed on the palette, or mixed on the paper. Using paint neat gives us the full value of the colour, but is not always the colour we want, so we must mix it with another colour or colours.

Mixing on the palette seems the obvious thing to do, and for most purposes it works well, but you can get more vibrant colours by letting the washes mix on the paper – resulting in a lovely soft merging colour that is ideal for flowers. Painting wet into wet is always somewhat hit and miss (see page 30),

but practise and you will soon have the confidence to handle the paint well.

mixing dark colours
There are occasions when you may need a near black; for this I use a mixture of the darkest colours I have in my palette – the actual colours will depend on how I see my subject. I never use black, as this seems such a dead colour, but prefer to use sepia, a very dark brown, or indigo, a dark inky blue, and play around with the mixes until I get the colour I want.

Using permanent rose or alizarin crimson, paint the shape of a geranium, and while the paint is wet drop in some cadmium red and see how it merges on the paper. When the paint is dry you can paint some detail over the washes.

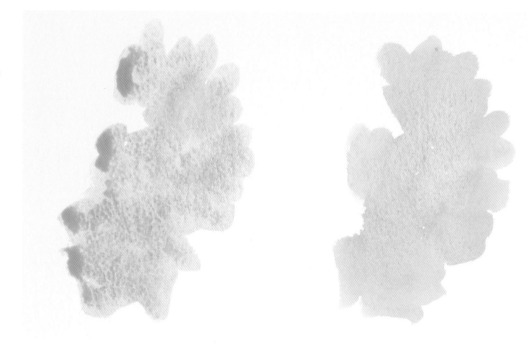

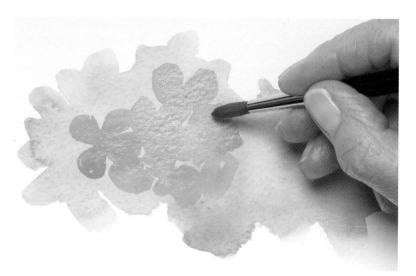

Here, the same base colour has been allowed to dry before the further details are painted over it. With many flowers it is difficult to achieve vibrancy unless you work in this way.

natural greens

Most leaves and stems are green, so it is an important colour to understand when painting flowers – you will need to have a range from light to dark, and need to know how to make greens. I prefer to mix my own, and try to stick to a light, medium and dark green, with the addition of blues or reds as required: the light green is not a watered-down version of the others – light does not mean watery.

Among readily available greens are sap green, a useful, bright and cheerful green, but liable to fade; olive green, a flat but pleasant green; viridian, a light and clear emerald green that is useful for mixing with earth colours; and Hooker's green, also useful when mixed with earth colours. There are all sorts of mixes you can make up, so experiment by varying the colours you use, and find out which greens are more transparent and which more opaque; and perhaps make up a chart that shows both ready-made and home-made colours.

GREENS

The two top greens here, olive green and sap green, are ready-made shades; all the others are mixes. Second row: ultramarine and cadmium yellow, ultramarine and yellow ochre, and Prussian blue and Winsor yellow. Bottom row: Prussian blue and burnt sienna, Winsor yellow and olive green, and cerulean blue and Winsor yellow.

earth colours

The earth colours – siennas, ochres and umbers – are basic to painting natural subjects. Where other pigments have plant, animal or metal origins, earth colours are derived from the earth and are more easy to produce. While they should be essential in your palette, be careful how you use them, as they can muddy flower tints if overemployed.

Of the basic earth colours, raw sienna is a beautiful transparent yellow; yellow ochre is similar, but more opaque; raw umber is a clear brown with a touch of green; burnt sienna, a reddish brown, is very useful for combining with blues to make greys, or with green-blues to make dark greens; and burnt umber is a darker red-brown that has similar uses to burnt sienna.

EARTHS

Top row: yellow ochre; raw umber; burnt sienna
Bottom row: burnt umber; raw sienna

light and shade

We need light to see our subject in the first place, and light combined with shade helps to define the form or shape. Light and shade also produce other effects, such as drama and variations in colour.

Colour can change under different lighting conditions, and we can affect this when painting indoors by using artificial light to our advantage – we can direct light onto a particular area we wish to highlight, and we can make silhouettes or reverse flowers out of a background, to give just a couple of examples. Light and shade also create patterns, and can be used to promote abstract shapes.

I find it helpful to work in three tones – light, medium and dark – and constantly remind myself to try to see light to dark and dark to light.

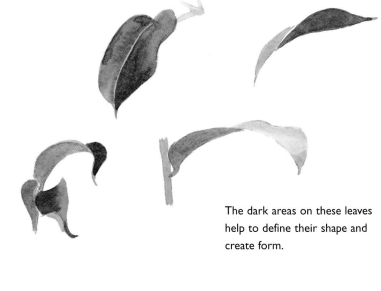

The dark areas on these leaves help to define their shape and create form.

The sunlight behind this pelargonium throws it into shadow. The dark tones suggest form and depth, with minimal detail.

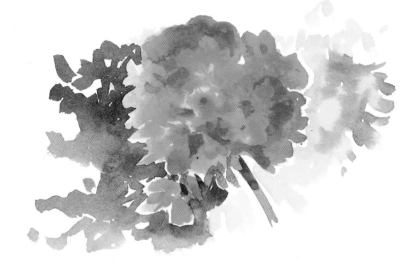

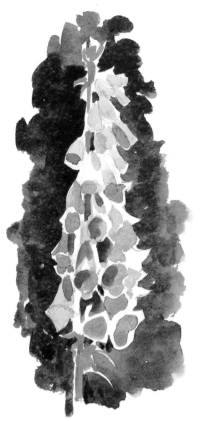

Although there is a fair amount of shade on this white foxglove dramatically lit by sunshine, the flower is obviously white. The clear silhouette helps to throw it into relief from the background.

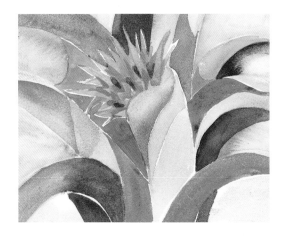

This bromeliad has been worked in an abstract way; the light and shade make interesting patterns and shapes without the use of direct light.

exercise: *light and shade*

step 1

Start by establishing the very lightest areas. Paint a light wash of alizarin crimson along the petals with a No. 8 brush, working freely to set the position. Use quite wet and soft washes of Winsor yellow mixed with a little olive green for the flower centres, again working loosely.

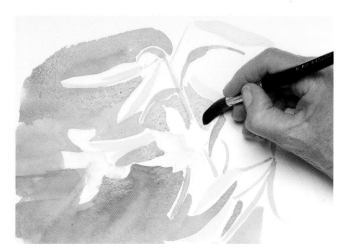

step 2

Add the leaves that are in sunlight with a mix of cadmium yellow and Prussian blue, using the shape of the brush to suggest the movement of the leaves. When the first washes have dried, use a No. 12 brush to apply broad washes of brown madder for the terracotta tile background, even where it will be overpainted for the shaded areas. Work into the negative shapes of the leaves and petals.

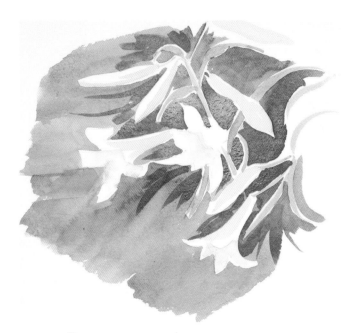

step 3

To show the mass of green in the shaded areas, mix a wash of cadmium yellow and ultramarine, and cut this around the light leaves and petals, creating new leaf shapes over the terracotta wash. This first dark colour has the effect of putting the lighter ones into relief.

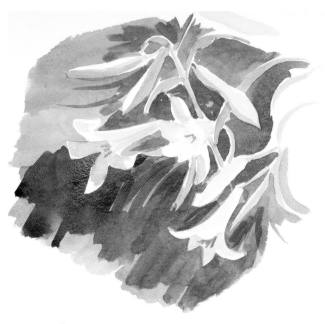

step 4

With the No. 8 brush, apply a very light mix of brown madder and ultramarine to create the shadows on the white petals; leave the paper white where required. Then use a stronger mix of the same colours and the No. 12 brush for the shadows on the wall – this is the darkest tone in the painting, so don't apply it indiscriminately; let the lightest leaves and sunlit areas of the wall show up. Finish by adding the flower's stamens with cadmium red and cadmium yellow.

tone and tonal values

Whatever you are painting, it is easy to be seduced by the idea of the flower shape and to forget all the colours and tones that make it so attractive. When the sun is shining onto a flower it is possible to see the lights and darks, but where there is no strong light you have to rely on the actual colour that you see – for example, a light-coloured flower can be contrasted with a darker background of leaves. If you are painting a white flower, using a darker background makes it possible to define the edges.

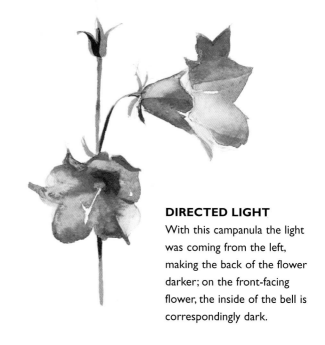

DIRECTED LIGHT

With this campanula the light was coming from the left, making the back of the flower darker; on the front-facing flower, the inside of the bell is correspondingly dark.

USING BACKGROUND

This hibiscus was painted in a greenhouse with no direct light on the flower, but the painting relied on the tonal values of the dark colours behind the subject. Other, lighter greens provide a sense of distance.

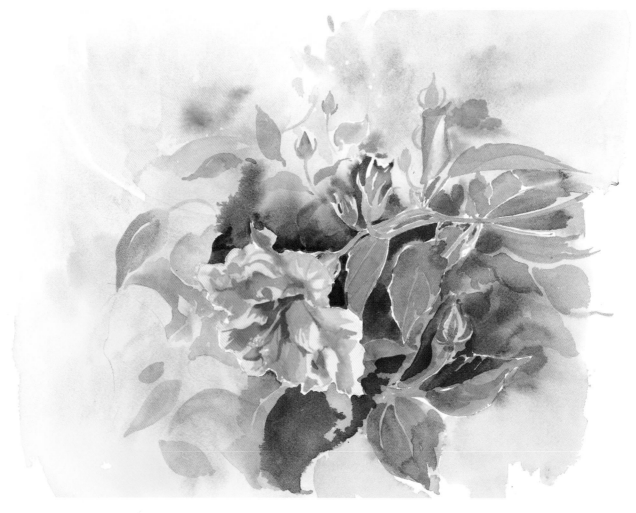

The tonal values of a subject can often be explained by working in one colour (monochrome) and using the range of tones within that colour, which helps to break down detail and enables you to control the composition. Look at the overall shapes first, then identify the light and dark areas using tones of one colour. A subsequent colour study of the same subject will be clearer.

I often look for the darkest tone in a painting, paint it in early on and use it as the basis for the rest of the work. This is pretty well the opposite of working from light to dark, but it need only be employed over a small area.

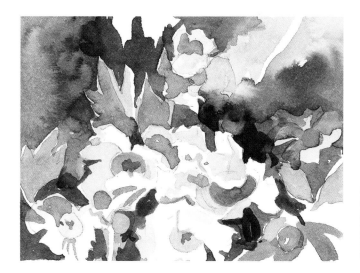

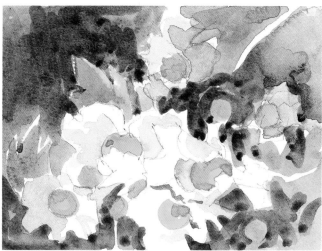

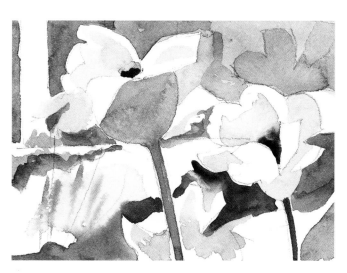

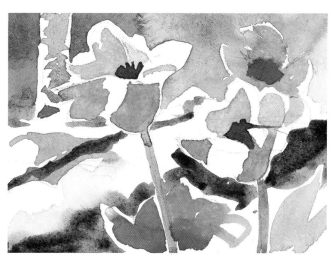

MONOCHROME AND COLOUR

Thumbnail rough monochrome sketches such as these give some idea of tonal values; they don't take too long, and almost certainly save time when you start to work in colour. I used Payne's grey for the tonal studies. These small sketches are also useful as compositional aids, as they help to clear the mind of extraneous detail.

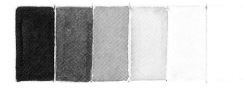

TONAL SCALE

A tonal scale of this type can help you to sort the tonal values out, and is quite easy to make. It shows tones from black through to white, with the mid-tones appearing very similar. Keep such a scale in mind when planning a painting, and look for the lightest and darkest points in any composition.

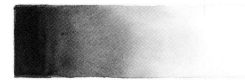

composition

When considering what you are going to put into your painting, there are quite a few points to mull over and choices to make. For instance, what is most important – what attracted you initially – colour, shadows, setting or subject? The time of day, location and weather will all have parts to play, too.

To help you decide it is a good idea to make some small sketches before you begin your painting. These little drawings, or thumbnails, are a useful aid to making up your mind. You can look through a viewfinder or make a rectangle – horizontal or upright – with your hands, and then transfer the image you want onto the paper of a sketchbook.

The eye level, the level from which the subject is seen, is important – sitting or standing can make a vast difference. Likewise, when considering your composition, is your eye led to the focal point of the painting, or does the movement and placing of the elements lead it away from that point?

Curving lines and diagonals help to create movement and direction, while uprights create stability and horizontal lines can cause a feeling of flatness. In among all these considerations, sometimes a straightforward and simple idea is best.

THUMBNAILS
This thumbnail sketch, showing a pathway into a garden, measures only 75 x 100mm (3 x 4in). Making this type of sketch is a kind of visual note-taking, and helps you to sort out the perspective and the tonal values in the scene.

AIDE-MEMOIRE
Even smaller at 75 x 75mm (3 x 3in), this sketch of a window in France is a straightforward, quickly drawn view. There is a little shading to help set the scene, and colour can always be added later.

perspective

Most of the time when painting flowers you don't need to consider perspective, but a basic knowledge of the subject can be invaluable when painting or drawing a garden, patio or greenhouse, for example.

First, make a mental note of your eye level in the scene – if you hold a pencil level with your eye, this is the eye level, which is also the horizon line. All objects that recede away from you meet this line, and where they disappear from view is called the vanishing point. There can be just one, or many vanishing points in a picture.

To a certain extent you can trust the evidence of your eyes when sketching and planning perspective; if you are unsure, you can measure and compare factors in the scene – the width of a path compared to its length, the height of an object compared to its width, and so on.

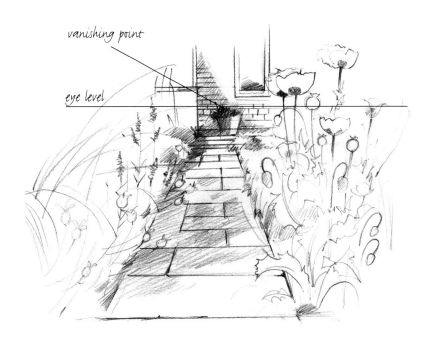

vanishing point

eye level

MULTIPLE VANISHING POINTS

In this sketch, made while sheltering from the rain in a greenhouse, there are three different vanishing points – the path, the walls and door. Often vanishing points will be off the paper; I find it helpful to use a long ruler to extend the lines on the paper to check for accuracy.

ONE-POINT PERSPECTIVE

This drawing is a good example of one-point perspective, where all the lines join at a single vanishing point. Here, the parallel lines of the path continue invisibly until they converge at the eye level line above the top of the flowerpot.

CREATING DISTANCE

Other factors that give a sense of perspective are recession and colour – here, the light shades of the sky and hills give a feeling of distance, or aerial perspective, which is reinforced by the strong yellow of the field before the house and the rich colours in the immediate foreground.

formats and scale

As an artist it is important to be aware of your options, and this can start with the shape and size in which you choose to make your work – it can also be stimulating to change from your usual working practices and be open to possibilities.

formats
The three basic formats are portrait (upright), landscape (horizontal) and square. When planning a painting, you can play around with a viewfinder or two L-shaped pieces of black card to frame the scene and then decide on which works best; thumbnail sketches or tracings are alternative methods.

I tend to paint even small subjects on a large sheet of paper so that I can extend my composition if necessary. Painting on too small a size can cramp your style, and there is a tendency to squeeze a composition if the paper is too narrow or small. That said, it doesn't always follow that the larger the painting, the more impressive it is; small works can be equally interesting.

choosing the format
The original painting (below) was painted in a landscape format on a sheet of 380 x 520mm (15 x 20in) paper with plenty of white space around it. However, it seemed to lend itself to the idea of being cropped and changing from

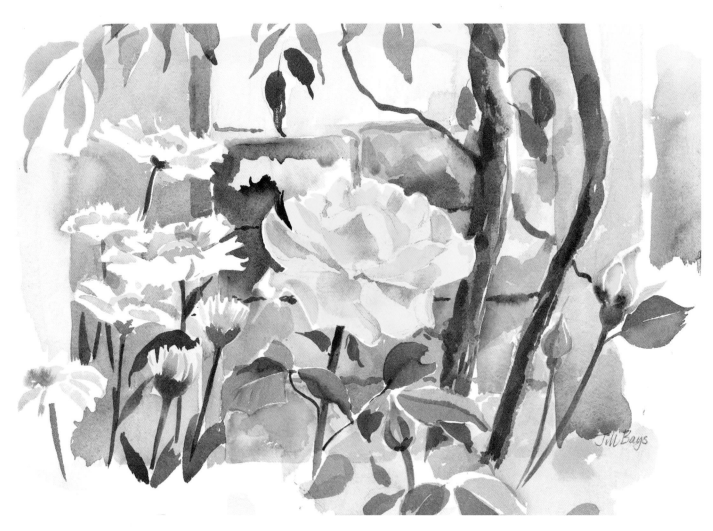

LANDSCAPE FORMAT
This painting was made in landscape format; the tracings (opposite) show how the same painting would look in portrait or square.

SQUARE FORMAT

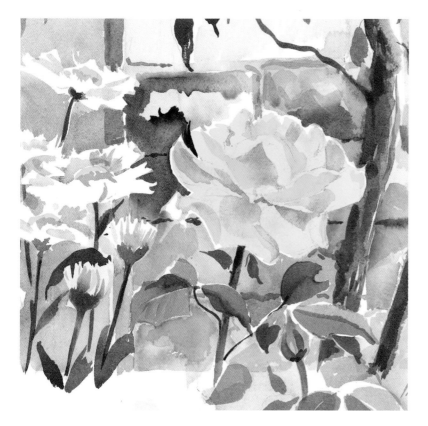

painting size

In order to give yourself the option of changing the format of a painting, you need to be quite generous in the size of your work. I tend to paint life-size, the same size as the subject, and even enlarge some smaller flowers – this can be fun, and can lead to all kinds of abstract shapes that are interesting to explore when you crop into them.

other formats

There are other formats you can explore – long and narrow, upright or horizontal. Most flowers are upright, and so a tall, narrow format and framing could be just right. Take a look at paintings in galleries and exhibitions, and see how they have been mounted and framed for effect.

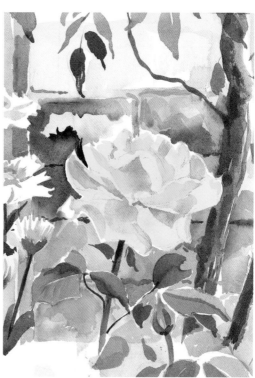

PORTRAIT FORMAT (right)

landscape to portrait format – or even as a square format. My two L-shaped pieces of card were useful here in determining and altering the shape. This method doesn't always work, however – you have to be careful not to make the painting look cut off abruptly.

cropping

Landscape, portrait and square shapes are only some of the options available. You may have parts of a painting you like and others that are not so important, so why not crop into a section? This is rather like using a zoom lens on a camera, where you can choose your view in close-up. Decide on what you think is the most important part of the painting, and work from there.

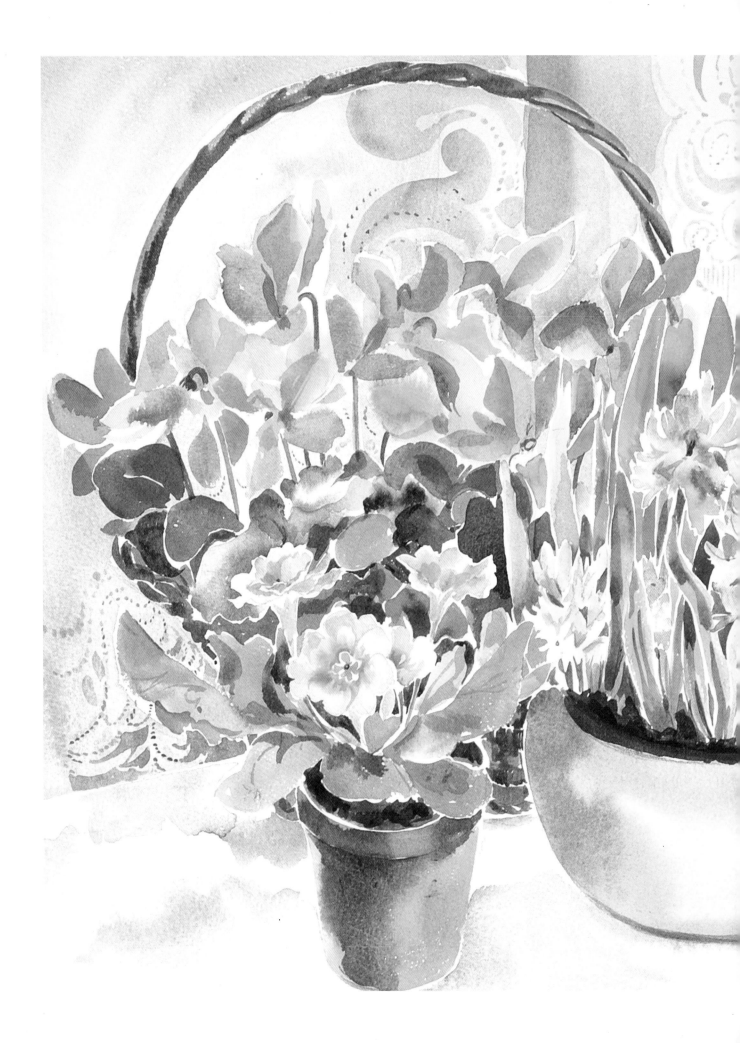

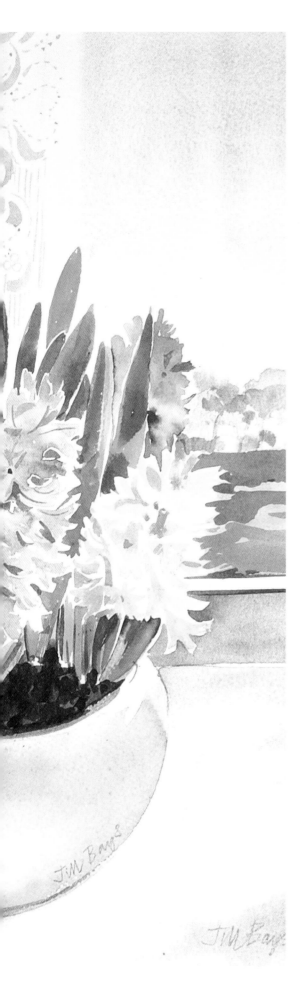

The projects

The six projects in this section are built around a series of Saturday exercises that lead to a finished Sunday painting, which incorporates the techniques learned in the exercises. These two days don't necessarily have to be a weekend, but it is important to have continuity and to get into the habit of painting – and a weekend happens to be when most of us have the time.

Each Sunday project includes a complete list of the colours, brushes and materials I used to complete the painting; you then have the choice to change or adapt these once you feel confident. You can also paint from the reference material provided, or use the information to create your own artwork. By the time you have worked through the exercises and projects – remember, don't rush! – you should have a good grounding in watercolour techniques and be able to go on to painting flowers in your own way.

project 1 · single flowers

exercise 1: leaving white lines

I enjoy making flower studies, turning the flower this way and that, drawing it in pencil then finishing it in watercolour – by the time I have finished, I feel I really know the flower. It is essential to study flower shapes and to learn about the shadows and colours as well as the main subject; and if a leaf is included, so much the better, as you can think about how to achieve the particular green required. Analyze the character of the flower itself and make your studies without being distracted by techniques at this early stage.

In watercolour paintings, you will notice that fine white lines are often left between different parts and colours. The reason behind this is to make sure that one colour does not run into another while they are both still wet; and if the paint is dry, you can usually overpaint without it running – but this is by no means always the case.

As you become more experienced and your hand becomes steadier and more confident in handling brush and paint, you will find that leaving these tiny white lines is an ideal way to control your washes.

TIP

• If you want to study an upright flower without being distracted by a vase, stick the flower into some soaked Oasis, a green stiff foam used by flower arrangers which is available from most florists. •

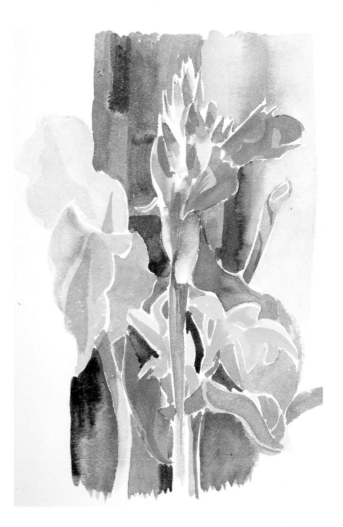

exercise 2: shadow colours

Shadows on flowers are elusive and difficult to capture. On white flowers the shadows often appear grey, but they could have a touch of green, blue or pink in them. However, flowers that have yellow, red, blue or pink petals need to be painted with shadows that do not make the flower look muddy, so you have to be careful with your colour mixes – for example, a blue-grey shadow on a yellow flower may turn to green. With all shadows it is best to practise on spare or scrap paper, perhaps making notes of which mixes and combinations are successful or otherwise. Observation is very important, and this will show that shadow colours may simply be darker versions of the flower colour.

CAMPANULA

This blue campanula uses a darker version of the flower colour for the shadow; alternatively, you could use cobalt blue for the flower and an ultramarine shadow.

RED TULIP

The shadow colours here are darker versions of the tulip colour – think of light, medium and dark tones. The lightest part is a tint of the red on the left, followed by a slightly darker tint; and inside the flower is a more saturated version of the same red.

TIP

● Depending on how they are made, reds can be bluer or browner – alizarin crimson is more blue, while cadmium red is browner – and this can affect your choice of which to use. Always try out the colour on a piece of scrap paper first. ●

DAFFODIL

Daffodils are difficult – it is hard to decide on the shadow colours, which are sometimes grey or green. Again, a darker version of the flower yellow is useful, but at all times try to keep the colours clean.

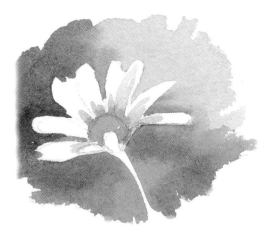

TIP

● Warm and cool colours can play a part in choosing the right shadow colour – reds are warm, while blues tend to be cool. For example, a warm yellow could be shadowed by a cooler blue grey, and a cool blue could have a warmer shadow. Try out the various combinations. ●

DAISIES

White daisies usually have grey-blue shadows, as here. One thing to watch for is the use of earth colours, which can tend to make your shadows look dirty.

exercise 3: flower centres

Depending on the structure of the flower, some flower heads have intricate centres with pistils and stamens that demand to be painted in great detail, others may appear as a more general mass that can be suggested with a soft, amorphous effect.

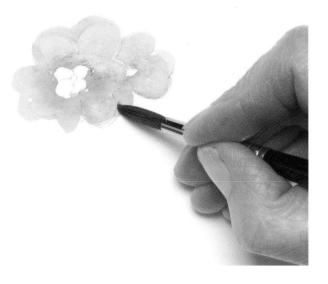

step 1

For this primula, mix cadmium red and cadmium yellow to create a soft orange, then use a No. 12 brush to paint the petals, leaving a small hole of white paper in the centre. While the paint is still wet, make up a darker orange and drop this on the petals around the centre. Allow to dry.

step 2

Using the No. 12 or a No. 8 brush, paint the centre with a very light tint of cadmium yellow. Again, leave to dry completely.

step 3

Make a light green from ultramarine and cadmium yellow, then paint the pistils in the centre with a No. 4 brush, taking care to note the exact numnber in order to be accurate when achieving the fine detail.

TIP

• *Watercolour dries about 50 per cent lighter than when it is applied, so take this into consideration when painting. Although it is not always possible, try to achieve the right colour from the start, which will save too much overpainting and possible loss of freshness.* •

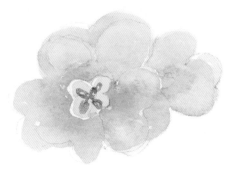

USING WATER

This lily uses a combination of techniques: after the flower and shadows were painted, the flower centre area was dampened with clean water before a little Winsor yellow was dropped in from the end of a brush. When this was dry, some sap green was laid to create depth in the trumpet. The stamens and pistil were painted when this was dry.

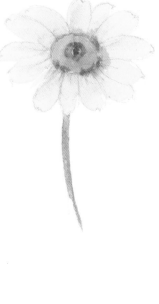

WET INTO WET

The centre of the pansy was drawn carefully, then a wash of mixed ultramarine and Winsor violet was painted on the petals, avoiding the flower centre. A darker wash was then applied before the petals were dry, and this was allowed to spread wet into wet. When this was dry, the centre was painted with cadmium yellow.

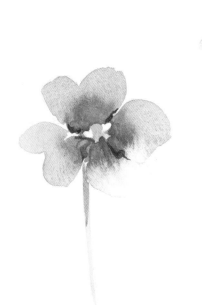

WET ON DRY

This daisy (far right) had a Winsor yellow wash laid over the whole flower, and sap green was then dropped into the centre from the tip of a brush. When this was dry, brighter cadmium yellow was painted over the petals and more green was applied to the centre. The petal shadows were added when the flower was dry.

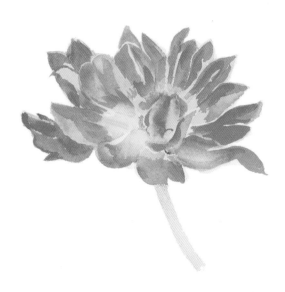

UNDERWASH

This double tulip was interesting to paint: because it was a very bright red, I laid a wash of cadmium yellow over the whole flower area as an underwash, and allowed it to dry completely. I then overpainted the petals with cadmium red to achieve a brilliant colour, leaving the centre yellow and adding a touch of sap green once this red was dry.

51

tulip

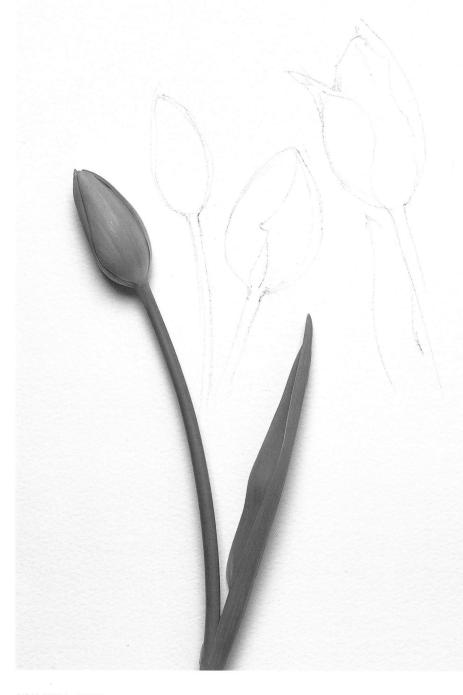

This delicate pink tulip caught my eye, and its very simplicity made me want to paint it. The gentle goblet shape is fairly easy to draw, and a single flower should not be too daunting. It is often difficult knowing where to start, but here there is no excuse – if you can handle a pencil and a brush, there is no better way to get going. In this painting you can put into practice the technique of leaving a fine line between wet colours, and you can concentrate on shadows.

YOU WILL NEED

Colours

- permanent rose

- sap green

- burnt sienna

- ultramarine

- Winsor yellow

- brown madder alizarin

Paper and other equipment
- Bockingford NOT 300gsm (140lb)
- 2B pencil
- soft eraser
- clean water

Brushes
- No. 8 round
- No. 4 round

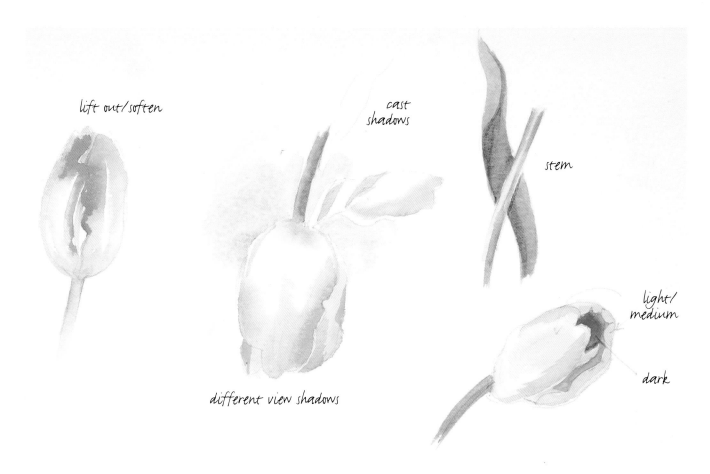

lift out/soften

cast shadows

stem

different view shadows

light/ medium

dark

GETTING TO KNOW THE FLOWER

In order to get to know a flower it is useful to make sketches, perhaps in pencil or using colour, as here. You can draw the flower from every angle and practise the colours of the petals, leaves, stem and shadows. The more you look, the more you will notice. Ask yourself some questions: what colour is the inside? How do I paint a cast shadow? What happens to the leaf as it goes behind the stem? You could make such studies in a sketchbook and keep them for reference later.

INITIAL DRAWING

Using a 2B pencil, lightly sketch in the shape of the flower head, and petals, stem and any leaves. With a cut flower, as here, you can lay it on the paper to get the actual size – the pose chosen was one where the single leaf came round behind the stem and head. As you can see from the steps on the next pages, by the time I came to draw the sketch, the tulip petals had started to open.

53

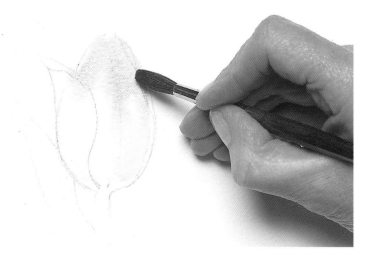

step 1

Use a No. 8 round brush to wet the whole flower head with clean water, then, while it is still wet, load the brush with a little wet permanent rose and touch it to the water at the top. The pigment will spread across the water down the wet area, resulting in a pale wet-into-wet wash.

step 2

While this first wash is still wet, add some more permanent rose to it, using this application to pull the colours and the watery wash together. Follow the contours of the head and petals as you go, and blend in this more even layer of colour with the earlier one.

step 3

Make a wash of ultramarine and permanent rose – it is always a good idea to mix more than you are likely to need, as it is almost impossbile to make an exact match of a mix. Use a No. 4 round brush to paint in the purplish shadows and curved lines of the petals. Dilute some of the mix and use it to add strength of colour to the outer petals. Allow these washes to dry.

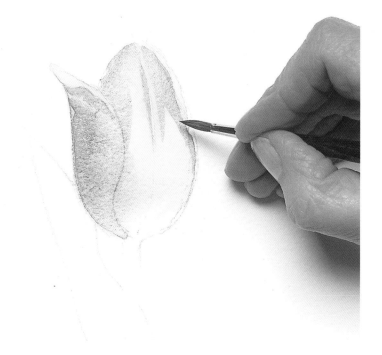

step 4

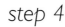

Make up a mix of sap green and Winsor yellow, and use the No. 8 round brush to apply the first wash on the leaf, leaving a tiny white line between the colour and the pencil line of the stalk, and between the wash and the flower head. To some of this mix add a little burnt sienna, and paint the stalk with the No. 4 round brush, again ensuring that the white demarcation lines remain intact.

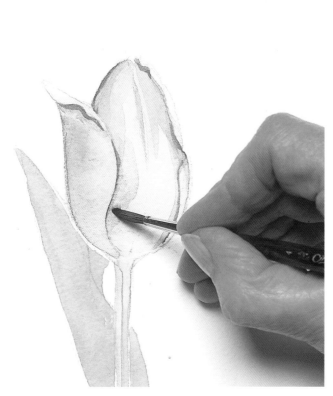

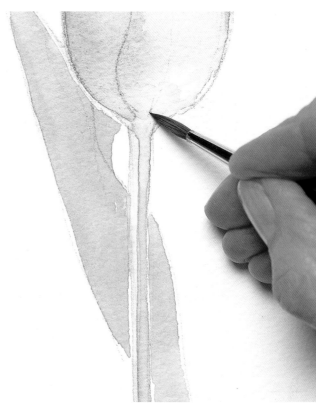

step 5

Add a little more sap green to the leaf mix, then use the No. 4 round brush carefully to add the shadow line on the stalk. While this is wet, wash the brush and apply clean water to the top of the stalk – the green colours should blend very softly into the pink of the petals at the bottom of the flower head. Allow to dry.

step 6

With the No. 4 round brush and a slightly stronger mix of ultramarine and permanent rose, strengthen the shadows and folds on the petals. Wash the brush again and use clean water to soften these new lines a little – but not to the extent that they start to spread over the main petal colour. Allow this wash and water to dry.

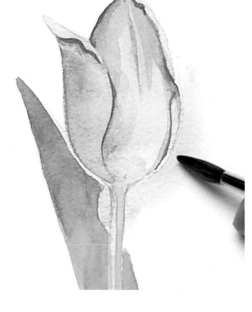

step 7

Carefully strengthen the leaf colour, applying a mix of sap green and burnt sienna with the No. 8 round brush; this will start to show different shades of green on the leaf. As before, try to leave the tiny white border lines between the leaf and flower head and stalk, and wash the brush and paint with clean water if the colour seems too strong.

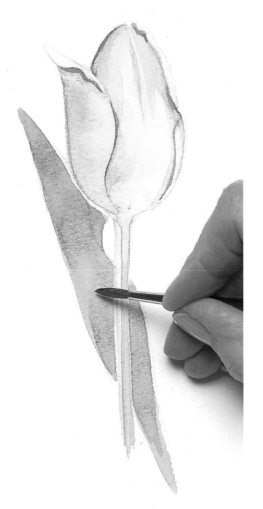

step 8

While the green wash is drying, make a mix of ultramarine and brown madder alizarin for the flower shadows. Use clean water and the No. 8 round brush to dampen the area outside the right-hand edge of the petals, then drop in a little of the mix, as in step 1, and allow the pigment to spread. Use the No. 4 round brush to fill the negative space between the stalk and leaf.

step 9

Slightly strengthen the sap green and burnt sienna mix, and use the No. 4 round brush to darken the area of the leaf that is in shadow from the curl. Deepen the colour on both sides of the stalk, and retain the white demarcation line to the left of the stalk.

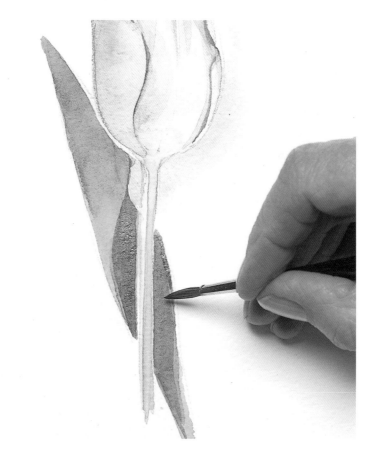

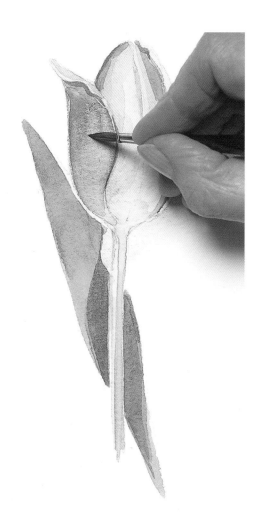

step 10

Step back and take a critical look at the painting at this stage – you may find that as the leaf colours have been strengthened, those of the flower head and petals seem to have lightened. If so, make a stronger mix of ultramarine and permanent rose and add further washes to the petals and perhaps their lines.

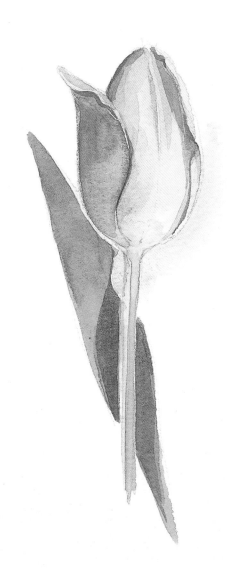

FINISHED PAINTING 178 x 125mm (7 x 5in)
I hope your study has paid off and that you are rewarded with a convincing painting, as this kind of observation will help you enormously as you progress. In this study of a single flower and leaf there are techniques that you will use again and again, including working with wet paint and handling your brush with confidence. I try to paint flowers life-size and like to hold a single flower in my non-painting hand, although this is not always possible.

project 2 · groups of flowers

exercise 1: negative shapes

Painting groups of flowers always presents a challenge – the flowers turn this way and that, and each one seems to have its own character. Even in a group the individual flowers need to be studied and drawn, and the more drawing you do first, the better the result. You have to think ahead (not one of my strong points) and work out a strategy. Look at negative shapes and decide whether to use masking fluid. As you work, think about colours, shadow colours, dark areas and light-dark contrasts.

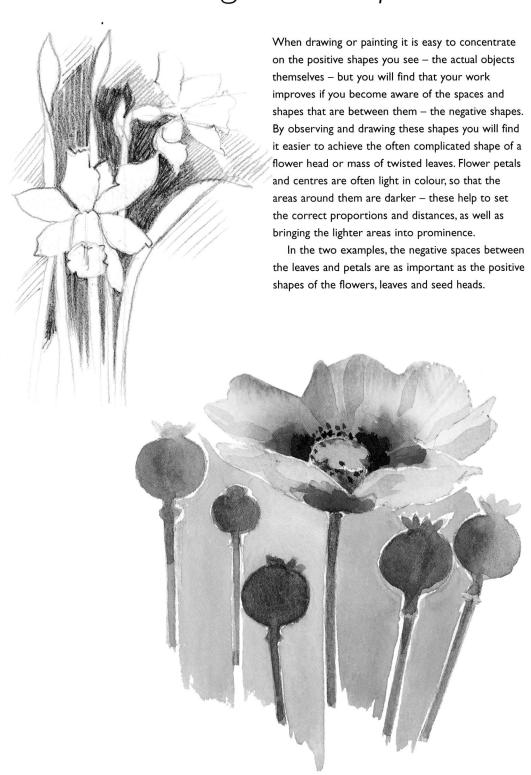

When drawing or painting it is easy to concentrate on the positive shapes you see – the actual objects themselves – but you will find that your work improves if you become aware of the spaces and shapes that are between them – the negative shapes. By observing and drawing these shapes you will find it easier to achieve the often complicated shape of a flower head or mass of twisted leaves. Flower petals and centres are often light in colour, so that the areas around them are darker – these help to set the correct proportions and distances, as well as bringing the lighter areas into prominence.

In the two examples, the negative spaces between the leaves and petals are as important as the positive shapes of the flowers, leaves and seed heads.

exercise 2: shadow colours

Shadow colours on flowers can often be obtained by using a darker version of the colours already applied. If you decide that you need more depth in your shadows, use a stronger mix – try not to mix more than two colours together, or the flower may appear muddy.

CHERRY

This flowering cherry was painted very wet in pink. Touches of ultramarine were dropped in, and these mixed with the pink to create the purple-grey shadow.

SWEET PEAS

These delicate sweet peas, painted in permanent rose, needed only a slightly darker wash of the same colour to create the shadows.

TULIP

This tulip was painted all over very loosely with cadmium yellow. The shadow colours were dropped in wet into wet – the grey-reddish mix of ultramarine and brown madder alizarin changed colour slightly as it blended with and dried on the yellow.

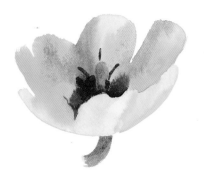

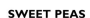

TIP

• *Shadow colours require a great deal of accurate observation. Look at the flower and decide whether the shadow is warm (reddish) or cool (blue) or grey or green, and then spend a few minutes testing out washes on a spare piece of paper.* •

PANSY AND ROSE

The white areas of this lovely white-and-purple pansy required only a slight blue/grey shadow colour, which was achieved using ultramarine and brown madder alizarin. In contrast, the shadow colours on the white rose are a greenish blue, made with a mix of ultramarine and brown madder, with a touch of Winsor yellow.

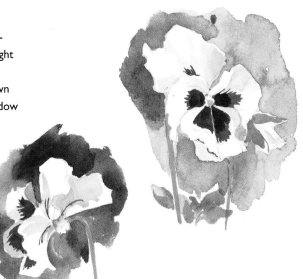

exercise 3: using masking fluid on white paper

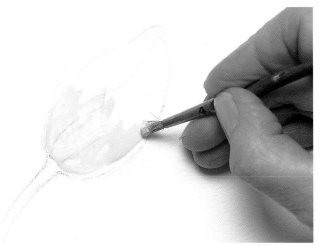

step 1

Set up your subject and draw the outlines lightly with a 2B pencil. When you are happy with the shape, apply masking fluid to fill the area to be masked – you can use an old brush, or a pen, stick or masking fluid with an applicator, to apply the fluid. While the masking fluid is drying, clean the brush, pen or applicator with washing-up liquid.

step 2

Allow the masking fluid to dry thoroughly – you can use a hairdryer to speed this process, but don't do this until the masking fluid is at least tacky to the touch, otherwise the air may change the shape of the fluid. Then make up a mix of ultramarine and apply it with side-to-side strokes of a No. 12 round brush, working across and over the masking fluid.

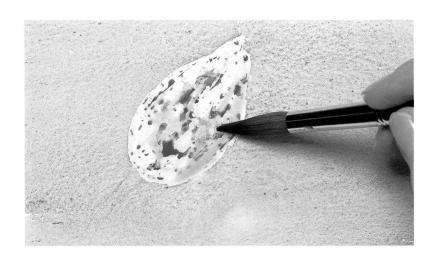

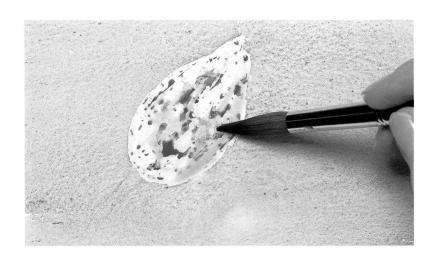

step 3

Let the wash dry completely, including any pools or puddles on the masking fluid, then rub at the masking fluid from one edge until it starts to come away from the paper. You can work quite firmly, as long as the paper is not too thin, and you may even find that whole strips of dried masking fluid come off in one go.

TIP

• Before using a brush to apply masking fluid, dip it into washing-up liquid, as it will be easier to clean afterwards. Also, remove masking fluid fairly promptly when it is dry, as it can tear the paper if left too long. •

exercise 4: using masking fluid over a wash

step 1

As with the previous exercise, draw the shape of the flower with a 2B pencil. Make up a light mix of alizarin crimson with a touch of ultramarine, and apply this from side-to-side over the drawing and to both sides with a No. 12 round brush. It is vital to allow this wash to dry thoroughly; when dry, strengthen the pencil marks if you wish. Then apply masking fluid and fill the edges of the flower shape as before. I used masking fluid with a special applicator, which is ideal for following the shape of the petals.

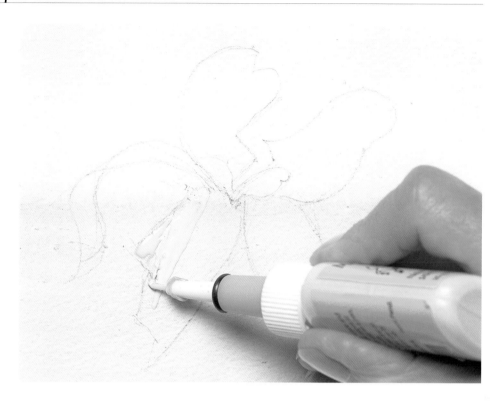

step 2

Let the masking fluid dry completely, again using a hairdryer at the latter stages if you wish, then make up a mix of ultramarine or any other contrasting, darker, colour and apply this over all the first wash. Allow to dry thoroughly, then use your finger carefully to rub the masking fluid off the first wash – you have to work gently in case the first wash was not completely dry when you applied the masking fluid, in which case the fluid may take some or all of the paint with it.

group of white flowers

I have always adored white flowers – they are so fresh and appealing, and their very whiteness makes them attractive. They are nearly always available, so you should be able to find them even in the depths of winter.

Whatever the colour of the flowers, if they are in a group, try to treat them as a group while being aware of the spaces between each flower and the leaves – the negative spaces that help your drawing. The important thing when using masking fluid is to think ahead and build in the time to allow it to dry before applying further washes. With the shadows, be careful if you mix more than two colours together, or the results may be muddy.

I used a limited palette for this project – only five colours – as this is a way to preserve unity in a painting.

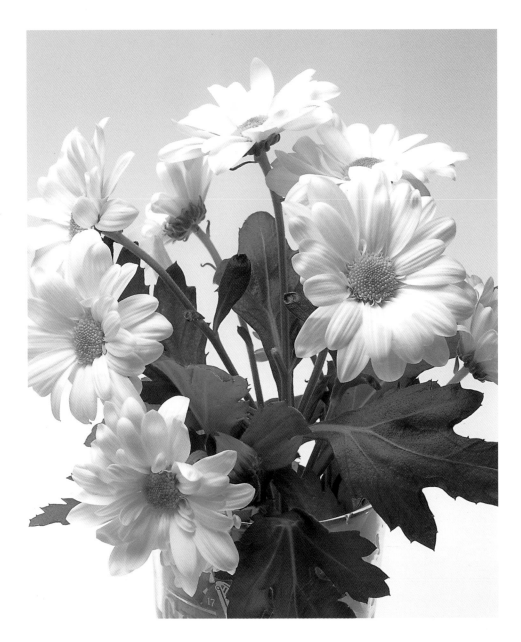

YOU WILL NEED

Colours

- ultramarine

- sap green

- Winsor yellow

- brown madder alizarin

- burnt sienna

Paper and other equipment
- Bockingford NOT 300gsm (140lb)
- masking fluid
- 2B pencil
- soft eraser
- sponge

- tissues or kitchen paper
- hairdryer (optional)

Brushes
- No. 12 round
- No. 8 round
- No. 4 round

INITIAL DRAWING

After arranging the flowers to their best advantage for your composition, use a 2B pencil to lightly sketch the shapes of the flowers and leaves, correcting and adjusting them as required. Keep the pencil marks light but strong enough to show you both where to apply the masking fluid and where to leave the paper blank for the white of the petals.

step 1

Either use masking fluid with an applicator or an old No. 10 round brush, or an inexpensive new one, to paint masking fluid carefully into the petals of the right-hand group of flowers. Work the fluid up to the pencil marks, and be ready to dab off any that goes over, using a tissue or piece of kitchen paper. Allow the masking fluid to dry completely, and clean the applicator or brush with washing-up liquid before the masking fluid dries on it.

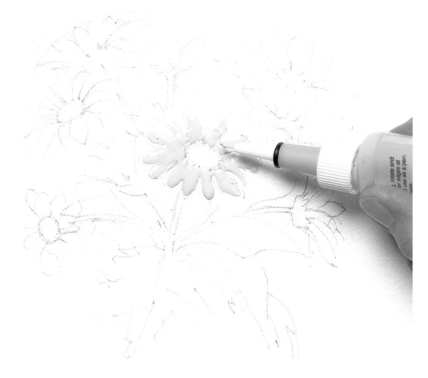

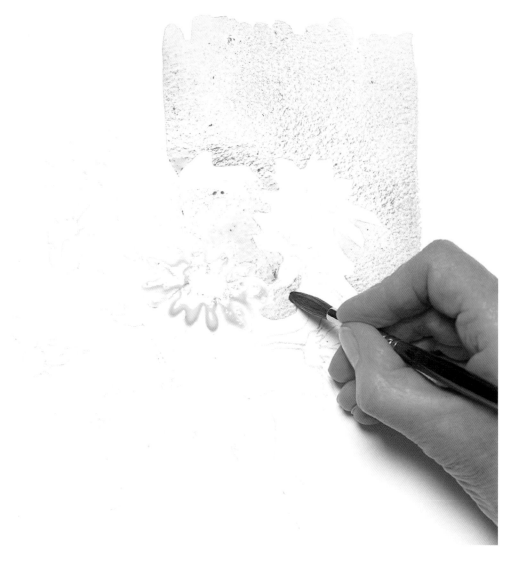

step 2

Make up a diluted wash of ultramarine, and use a No. 12 round brush to paint a wash down from the top of the picture. Paint around the negative shapes of the petals on the left, leaving the paper white, and over the dried masking fluid on the right. You can switch to a No. 8 or No. 4 round brush to reach the smallest parts with the wash.

step 3

Allow the ultramarine wash to dry thoroughly (it will take a different time from the masking fluid), then use a clean finger to remove the masking fluid and reveal the masked petal areas.

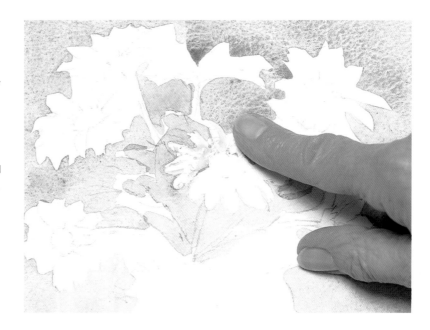

step 4

Mix ultramarine and brown madder alizarin to make a warm grey colour, then use the No. 4 round brush to apply the very lightest tones of the shadows on the petals. Remember to follow the contours of each petal, using your observation to ensure that the strokes are made accurately.

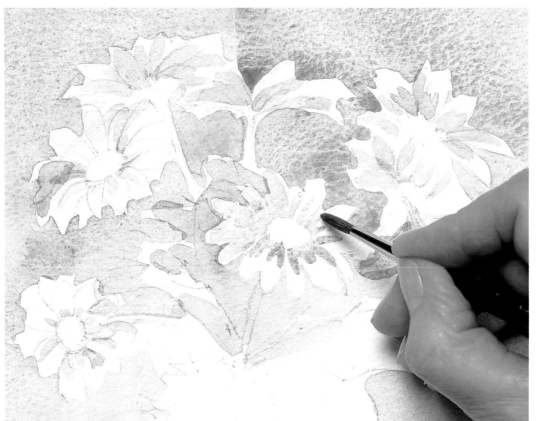

step 5

In addition to defining the contours of the petals, use the shadow mix from step 4 to indicate the 'negative' centre of each flower. Pull each stroke away from the border of each centre and petals. At this stage don't worry about gaps between the strokes, concentrate on establishing the definition and form of the petals.

step 6

For the lightest leaves, mix a light green from sap green and burnt sienna. Apply this to show where the mass of leaves are, again using the No. 4 round brush to work carefully into the detailed and smaller areas of the petals. The pencil marks should still show through this wash to help define the darker leaves and stems later.

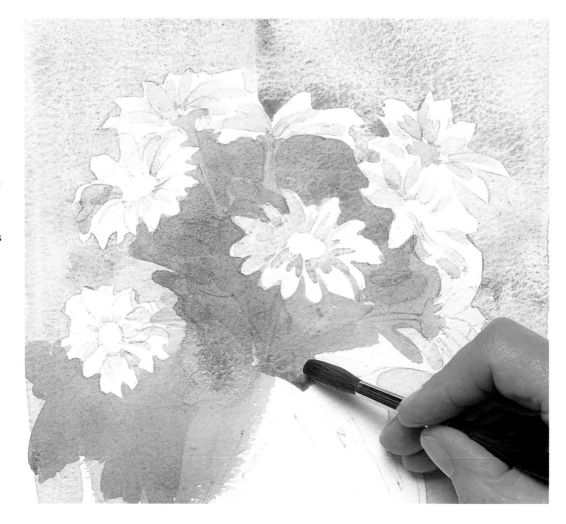

step 7

Add Winsor yellow to a small amount of the light green mix until it is a bright enough yellow for the flower centres without being too strident and unrealistic. Use the No. 4 round brush to paint the centres and allow them to dry slightly, then add a little of the original light green mix to indicate the shadows on the yellow.

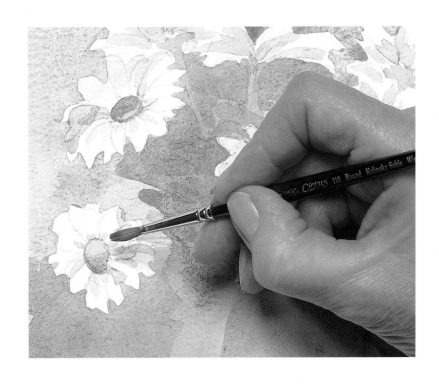

step 8

For the darker green of the prominent leaves, add ultramarine to the sap green and burnt sienna mix, then dilute about half of it. Use the No. 4 round brush to apply the diluted mix on the leaves, leaving the stems unpainted and a lighter green, and working into the negative white petals. Allow the first wash to dry a little, then build up the colour of the leaves in layers.

step 9

For the strongest and darkest leaf colours, apply the undiluted dark wash to the areas in shadow or on the underside, again building up the colour in layers and leaving the stems as pale green. Use the No. 8 round brush to paint the leaves behind the flowers at the top, and work into the negative petal shapes with the No. 4 round brush.

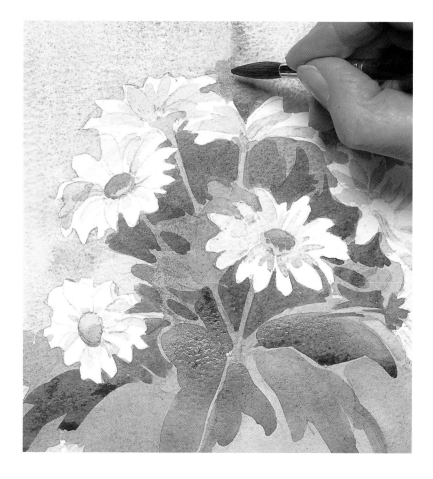

step 10

While the darkest washes are still wet, work into them with varying dilutions of the darkest wash, using each brush as required. Look for the differences in colour and tone between the leaves, and paint both into wet paint and over dry layers to get the right effect. At this stage of pulling the picture together, step back from the paper regularly and check that you are not in danger of overworking the colours and losing the freshness of the composition.

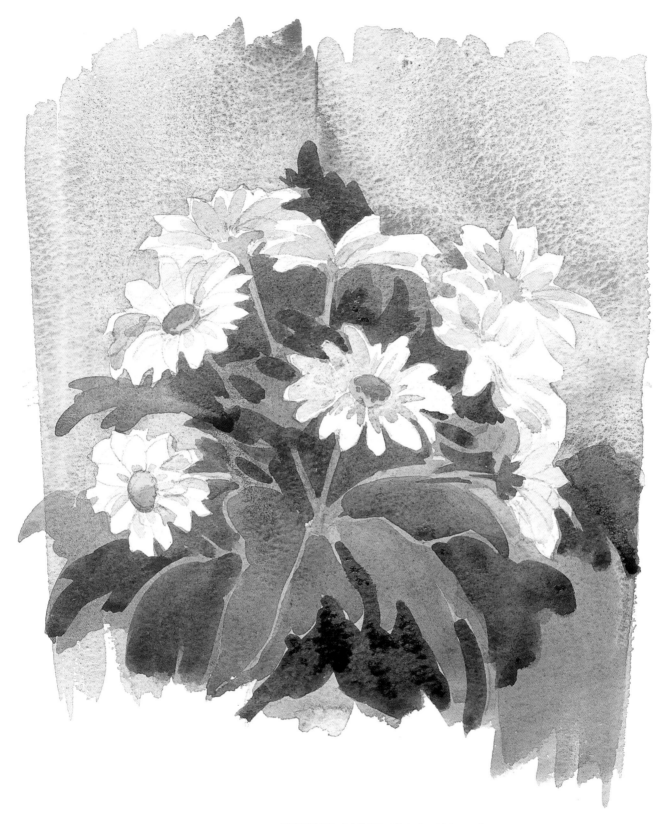

FINISHED PAINTING 200 x 178mm (8 x 7in)

The finished painting looks quite fresh and simple, the background wash holds the shape of the flowers, and the spaces between them look convincing. The flowers themselves face in different directions – quite a jump from painting a single flower – and work well, and their clean edges contrast with the soft, wet-into-wet background. The shadows and flower centres are straightforward without too much detail. I hope you enjoyed painting this subject – I did.

project 3 · spring flowers

How marvellous spring is after the winter – when daffodils come out you feel as if you can't wait to paint them, and almond, blackthorn, flowering cherry and many other trees are covered in blossom; I can't resist them, and bring sprigs indoors to paint them. Take your time, however – daffodils, for instance, have quite complicated shapes so observe them carefully and practise how to draw and paint them before embarking on a finished painting. The main ideas in any single flower study are simplicity and directness, keeping the colours fresh and clean, and the approach straightforward – there is such a temptation to overwork the paint, but resist it!

exercise 1: simple backgrounds

Adding a background to a painting can create another dimension – the background can be quite simple, such as a suggestion of colour or shadows, or could include trees, windows, hills or a still life. It can contrast with the subject, or be patterned or plain.

There are various ways of starting – for instance, you could paint the background first, leaving the subject as a negative shape, or you could paint around your subject after you have established the focal point. Whichever way you decide on, you should be capable of laying a wash with confidence; remember that watercolour paint will always dry much lighter than when applied, and always have enough wash ready. It is always a good idea to practise beforehand on scrap paper. I stand up to apply washes, as this gives me more arm room than sitting down.

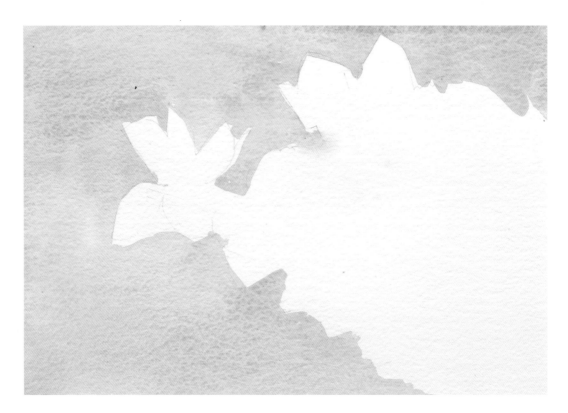

SINGLE COLOUR
You always need more wash than you think. Here, I used a wash of one colour and worked quickly without stopping, using my largest brush. Alternatively, you could dampen the paper before laying the wash.

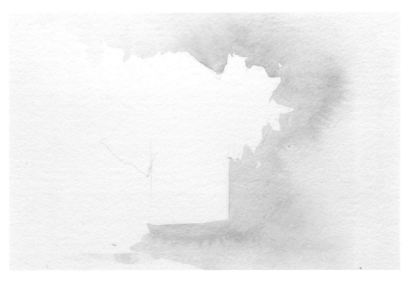

LIGHT BACKGROUND

If you paint the background first and need to put a wash behind where the subject is to be placed, this should be fairly light in colour, or you could quickly blot out the light or white areas with a piece of kitchen paper. Note that botanical artists mostly paint on white paper and do not include backgrounds in their studies.

GRADATED WASH

A colour-gradated wash is similar to the single-colour one, but uses two colours. If the first wash is still wet, any fresh colour that is dropped in will spread and mix on the paper.

BUILDING UP BACKGROUNDS

Soft, minimal washes can be used in similar ways to colour-gradated washes. Windows and window sills can be made into features, and a sky-like effect behind a still life can also be pleasant. In addition, you can incorporate shadowy tree forms to your background.

TIP

• *To achieve a smooth, flat wash, tip your painting surface up and down a number of times to get the paint to run smoothly.* •

exercise 2: arranging lighting

When you are setting up a still life, consider how you want to light it, and spend some time in trying out different arrangements. Natural lighting is always preferable, but may not be possible in all situations – a north light, or a similar one where the lighting is even, is ideal.

Be aware of local colour (where light reflecting from one part of a composition can change or affect another part) and of contrasts, and study light and dark shapes. Artificial light often changes colours and gives them a tungsten-yellow overtone; many artists find blue daylight-simulation bulbs, available at good art-materials stores, very helpful to counteract this effect.

Strong sunlight or artificial light can create interesting shadows or patterns, but may not be ideal for a straightforward rendition of a subject. Experiment with different lighting effects to achieve certain moods – try firelight, candlelight or a single spotlight at night.

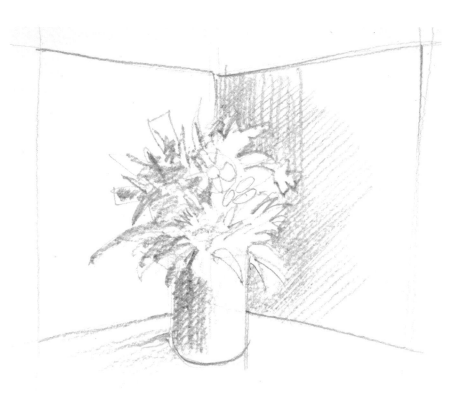

SIMPLE LIGHTING AIDS
A simple background can be set up from a piece of folded cardboard; this gives you a light side and a dark side – or you can cut out background distractions by placing plain fabric behind the flowers.

SIDE LIGHTING
If you are right-handed, try to arrange the light to come from the left so that the shadow from your hand and brush won't get in the way of the painting – and vice versa if you are left-handed.

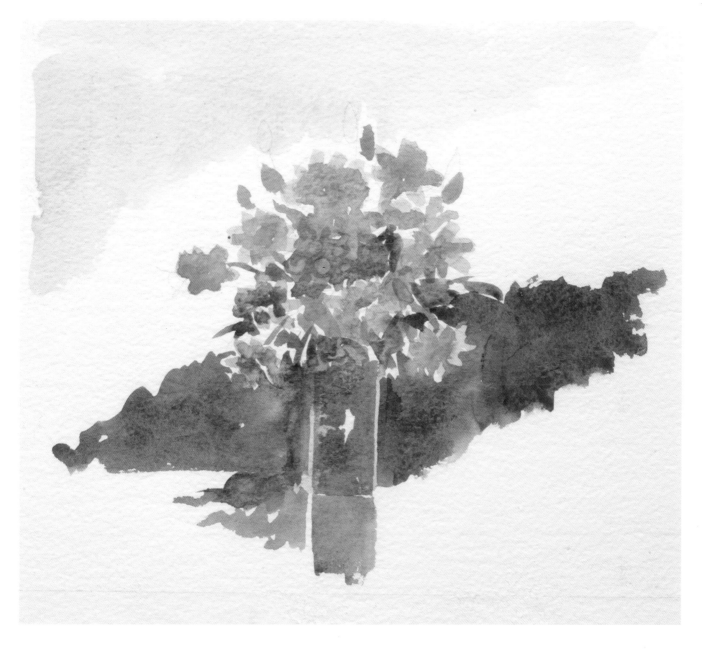

LIGHTING FROM BEHIND

Backlighting or rimlighting can be dramatic and exciting. Place your subject against a window and let the light shine around it, creating a set of interesting tonal values.

TIP

• *Even in daylight, a spotlight can be useful for creating strong shadows. Set the light at different angles for dramatic effects.* •

garden flowers

I collected this bunch of fresh spring flowers from my garden and arranged it loosely in an old jam jar. Although the height of the flowers might suggest a portrait (upright) format, the trailing stems at both sides bring width to the composition, so I settled on a landscape format. Painting the stems and leaves inside the glass of the jar is a quite different challenge, and allows you to work freely wet into wet.

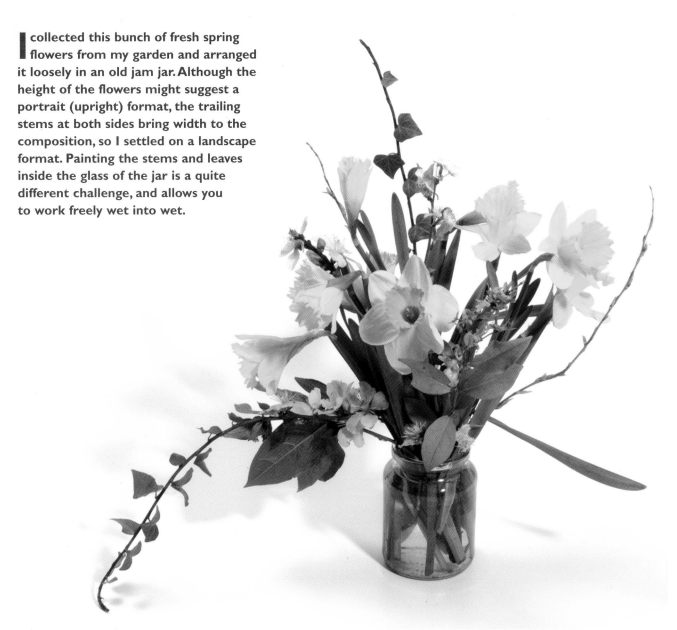

YOU WILL NEED

Colours

- Winsor yellow

- ultramarine

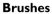
- brown madder

- olive green

- burnt sienna

- alizarin crimson

- cadmium red

- Prussian blue

- yellow ochre

Paper and other equipment
- Bockingford NOT 300gsm (140lb)
- 2B pencil
- soft eraser
- sponge
- clean water
- kitchen paper
- masking fluid

Brushes
- No. 12 round
- No. 8 round

INITIAL DRAWING

With a bunch of different flowers such as this, the aim of the initial drawing is to set the scene and establish the relationships of the positive shapes and negative spaces. Lightly sketch in the composition with a 2B pencil, paying particular attention to the ellipse shapes of the leaves and flower heads, and to the long stems and leaves. Take your time to get the proportions and dimensions right at this stage, and don't be afraid to change or amend as often as is required.

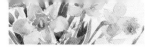

step 1

Make up a wash of Winsor yellow
and use a No. 12 round brush to
paint in the brightest yellow petals.
While this wash is still wet, mix a
little olive green into the yellow and
paint in the shadows on the petals so
that the colours blend – use kitchen
paper to blot off excess paint. For the
orange flower centre, apply a mixture
of Winsor yellow and cadmium red,
leaving a tiny white line between this
wash and the colours already applied.
Apply masking fluid over the areas for
the white petals, and allow to dry.

step 2

Make up a wash of
olive green and use
a No. 8 round brush
to paint the brightest
foreground leaves –
work freely, and paint
right up to the pencil
edges of the shapes.
Again, while this first
wash is still wet, add
ultramarine to the
green and apply this for
the shadows, allowing
the colours to blend.
For the daffodil leaves
and stalks, add Winsor
yellow to the green/
blue mix and apply
with the No. 8 round
brush.

step 3

Switch to the No. 12 round brush to apply the yellow/green/blue mixture to the daffodil stems and similar-coloured leaves across the composition; vary the amount of water and pigment in each mix according to the depth and brightness of colour required. Make up a mix of burnt sienna and Prussian blue and apply the darkest colours with the No. 8 round brush before going back to the lighter mix. Paint over the masking fluid where necessary.

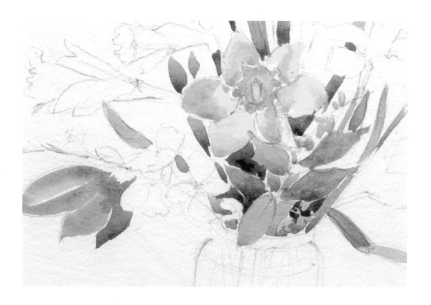

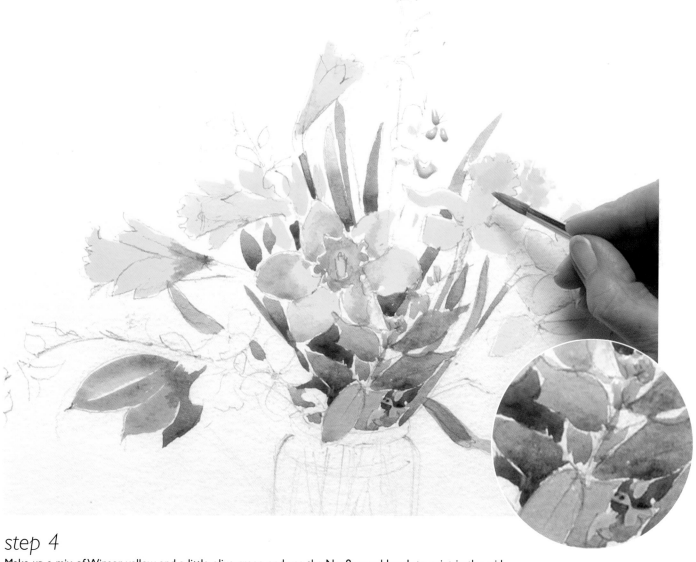

step 4

Make up a mix of Winsor yellow and a little olive green, and use the No. 8 round brush to paint in the mid-yellow colour of the other daffodils, concentrating on filling the shapes. As before, darken the mix with more olive green, and work wet into wet for the shadows on the petals. Use a slightly stronger, darker yellow and red mix than previously for the flower centres, and remember to leave a tiny white line between this and the wet yellow mixes.

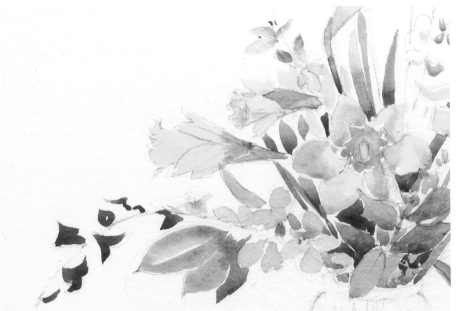

step 5

Mix a grey from ultramarine and brown madder with a touch of olive green, and apply this to the trailing stems of ivy with the No. 8 round brush; be aware that the colours always dry lighter. Use alizarin crimson for the pinks, dabbing the wet paint off with kitchen paper to create the lighter shades. Mix and apply a darker version of the burnt sienna and Prussian blue wash for the ivy leaves.

step 6

Use a strong, dark olive green wash for the ivy leaves at the top, and go over the ones at the side with it. Mix and apply burnt sienna and ultramarine for the darker stalks and stems, and use yellow ochre for the lighter ones. Still with the No. 8 round brush, apply a wash of Winsor yellow and olive green for the bright leaves among the smaller flowers. Leave the washes to dry completely and then rub away the masking fluid, then touch around the negative spaces of the white flowers, as well as any darkening needed on the outer leaves.

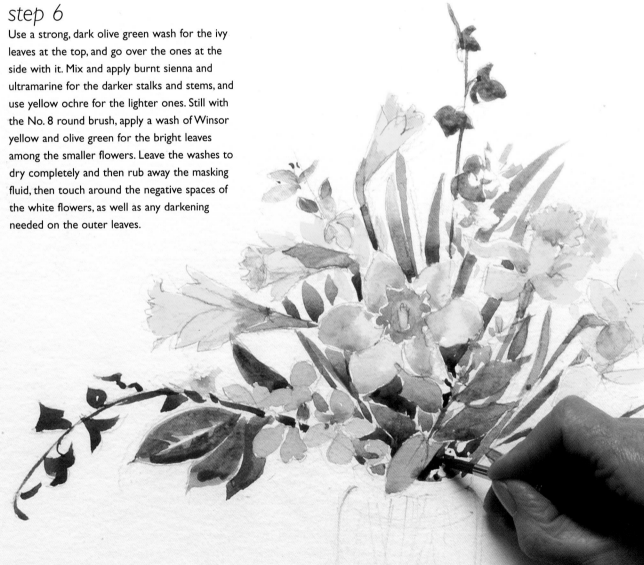

step 7

With the colours and shapes established, you can now start to concentrate on the details of the flowers and leaves – work between the various greens, browns, yellows and pinks across the painting, and look for where darkening or shadows may be required. Make up a dark olive green mix, and use the No. 12 round brush to paint the first stems seen inside the glass jar with long, free strokes; vary the darkness and brightness of the green as you go.

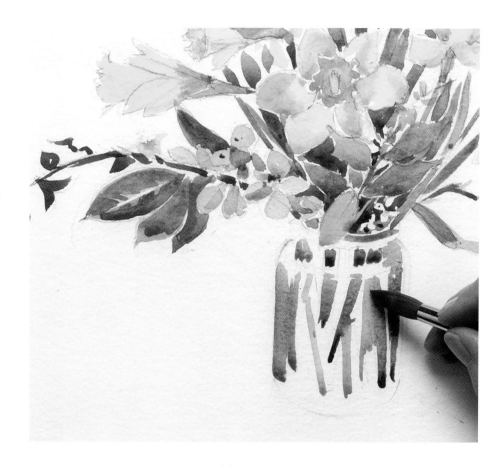

step 8

Continue to paint the colours inside the jar – at the same time as being careful to leave white paper as the highlights of the reflections, you can work wet into wet with the green and brown mixes, to produce a quite abstract, almost distorted effect.

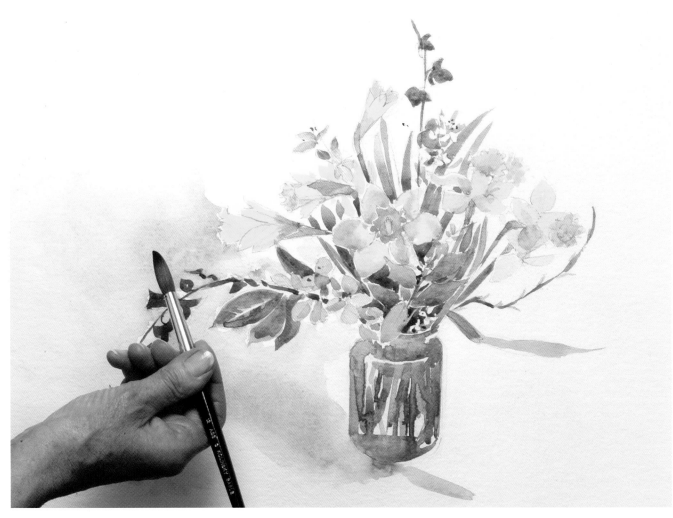

step 9

Make up a light mix of ultramarine and brown madder for the background shadows, then use a damp sponge to dampen the paper at the left-hand edge before applying the mix with the No. 12 round brush – this will have the effect of softening the shadow edges. Dilute the wash on the brush with clean water and apply this across the dry paint, again working into the negative shapes of the flowers and leaves. Use kitchen paper to dab off paint and prevent runs.

step 10

Use the alizarin crimson wash to add the pinks on the right-hand side, then step back from the painting and check carefully what still needs to be done to finish it. With all the colours in place, you will probably want to strengthen the darker ones across the whole composition; look at the flower centres in particular, and add more colour, using olive green for the very deepest shadows.

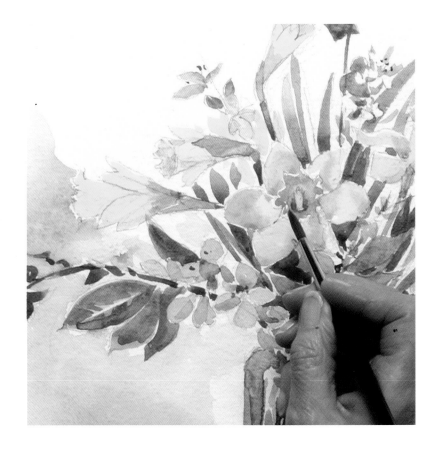

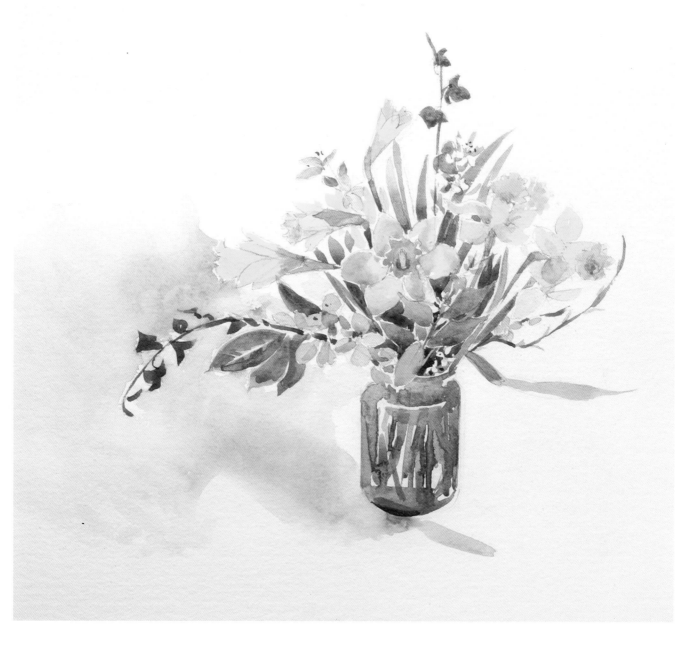

FINISHED PAINTING 255 x 178mm (10 x 7in)

I love painting simple arrangements where the flowers seem to fall into place quite naturally. My approach was quite relaxed – I didn't worry about going up the exact edges of the pencil lines, or if the paint ran a little. There is just the suggestion of a background, but you may want to extend it in your own study. Other flowers which have reasonably simple shapes are buttercups or ox-eye daisies, both of which look good in a jar and remind you of the countryside. Look on this painting as a start, use your imagination and get going on your own study!

project 4 · outdoor close-up

In this project, the Saturday exercises and Sunday painting introduce new elements – they demand close observation and a degree of choice about what kind of background you want to include, and how much, and show ways of painting multiheaded flowers. You can also think about how you are going to tackle a painting where the subject and background may come from different sources. For this kind of complexity I like to make studies in different media – pencil, line and wash – as well as watercolour, to help with the initial drawings.

exercise 1: more complex backgrounds

We have already discussed simple backgrounds in project 3 (see page 70); here are a few more ideas and suggestions for backgrounds that are more complex or busier. Getting the background right is often a matter of feeling confident about your brushwork – which, of course, take practice. The backgrounds here show how a range of effects can be achieved by using similar techniques with wet-into-wet washes.

MULTICOLOURED BACKGROUNDS

If your painting is to include flowers of various colours, base your background washes on these colours – perhaps yellow and pink, as here – and have a clear idea of your composition before you start. White flowers can be masked out or blotted as required. You can suggest other colours, but these are likely to merge as you apply them. When the washes are dry, you can build up the painting with further colour and detail.

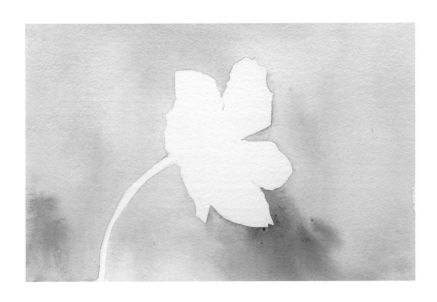

DARKER COLOURS

For a close-up of a flower with a darker background, a similar technique can be used. Run clear water around the outline of the masked-out flower, and paint on a colour which will run and mix on the paper, to correspond with the actual colours of the background you see. The soft merging of the paint can look attractive, but don't forget to use enough pigment to make the effect.

TIP

• *When painting wet into wet, it helps enormously to stretch all but the heaviest weights of paper beforehand. Painting on a firm, taut surface, that does not cockle or buckle when water or diluted washes are laid on it, is a great aid.* •

A LANDSCAPE BACKGROUND

A simple, soft landscape background (above and left) can provide an extra dimension to a flower painting – consider using fields, hills or mountains, for example. Practise and experiment as much as you can with these techniques before embarking on a detailed painting.

exercise 2: multiflowers and decorative patterns

Many flowers are composed of a mass of small florets. Try to represent the character of the flowers as a whole, as painting each single one would be too time-consuming and would appear forced. You can have fun with the colour, particularly when painting wet into wet, and when the washes dry you can start to indicate the odd individual flower, but keep the approach bold.

Flowers and plants growing naturally may have an untidy look, but on closer observation you can often find a pattern – leaves and flowers grow in repetitive ways, and this can bring order to your painting. In addition, you can introduce other sorts of pattern, such as shadows or patterned fabric for a contrasting background. You can repeat shapes and colours within a composition, so try out ideas and be creative.

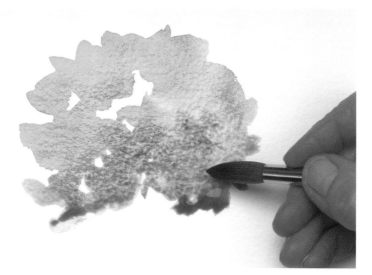

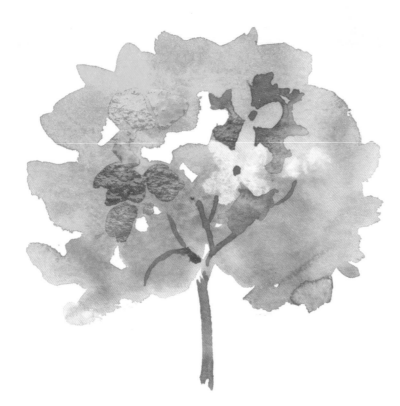

SINGLE FLOWER HEAD

step 1

Apply a first wash, dabbing the brush to create the small round petals at the edge of the flower. While this wash is still wet, drop in different colours and allow the paint to spread, blotting off if required.

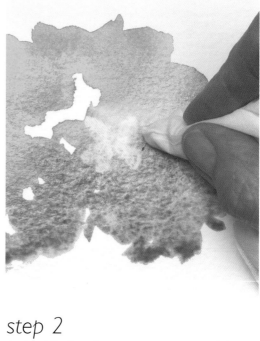

step 2

Again while the paint is wet, you can create light, single petal shapes by folding a piece of tissue paper or kitchen paper and blotting off small areas of wash. Allow to dry thoroughly before adding any further washes.

step 3

Use a small brush (No. 4 or No. 6 round) to paint into the dry washes; add positive, darker shapes and shadows, and create negative, lighter shapes by painting around them. Finish by painting the stalk.

WORKING WET AND DRY

Where the flowers are not crowded too tightly together, as with this agapanthus (left), you can use a diffused wet wash for the mass and then paint some of the individual flowers when the first wash is completely dry.

SIMPLE SILHOUETTES

To paint simple flower heads such as this buddleia, use a basic wash and indicate the stems and some individual flowers while it is still wet. Don't get too fussy about details, but make sure that the silhouette follows the character of the flower.

TIP

• Don't forget that you can use watersoluble coloured pencils to draw in small details over completely dry washes. •

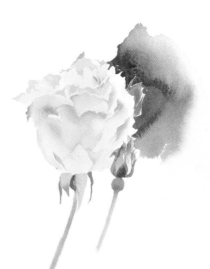

SPIRAL PATTERN

Flowers repeat shapes – the tightly packed petals of roses form spirals as they open out. This study of a pink rose helped me to understand the structure before it was included in a larger painting.

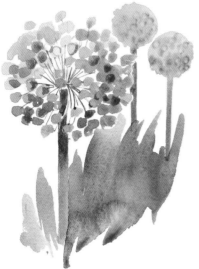

REPETITION

This lovely cactus flower incorporates repetitive shapes in both the petals and the stamens. The smooth surface of Hot-pressed paper is ideal for such detailed work.

DRAWING AND PAINTING

There is hardly a better example of natural pattern than ornamental alliums, whose flowers spring from the stem. If you want to add this kind of fine detail, use a dip pen to draw alongside the brushwork.

85

irises

his painting has two elements, the flowers and the background. The flowers are painted from life, but the background is contrived – although nature usually provides both elements, here I used a photograph to help the composition along. First, you need to decide which is the most important element: the flowers or the background. The flowers are strongly coloured and make the landscape paler in comparison; this helps it to recede and provide a feeling of distance – if both parts are the same strength, the recession will be lost.

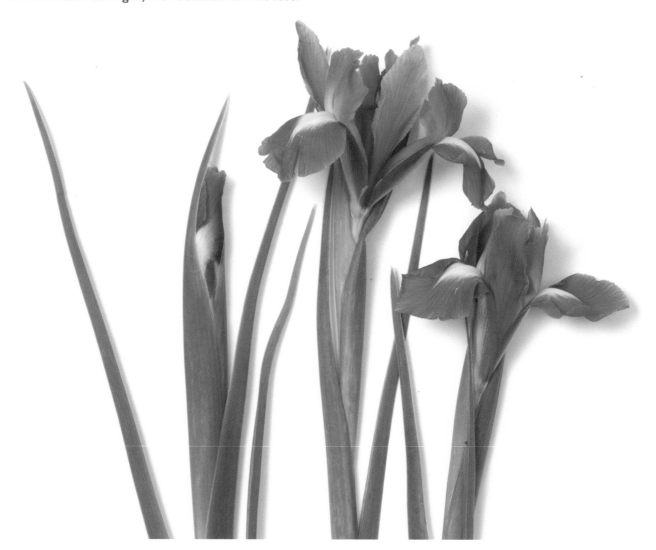

YOU WILL NEED

Colours

- Winsor violet

- Winsor yellow

- burnt sienna

- ultramarine

- Prussian blue

- yellow ochre

Paper and other equipment
- Bockingford NOT 300gsm (140lb)
- 2B pencil
- soft eraser
- sponge
- clean water

Brushes
- No. 12 round
- No. 8 round

INITIAL DRAWING

Using a 2B pencil, draw outwards lightly from the focal point of the composition – here, the central irises. With tall flowers such as these, you need to check the length of the stem and leaves, and correct them if they are not accurate. Look for and draw the negative spaces between the stems and leaves while drawing the other irises, then sketch in the background quite loosely – at this stage, you need only be concerned about blocking in the main shapes and areas. This sort of iris is normally about 51cm (20in) tall, so you wouldn't see irises against the sky, but you are using artistic licence here!

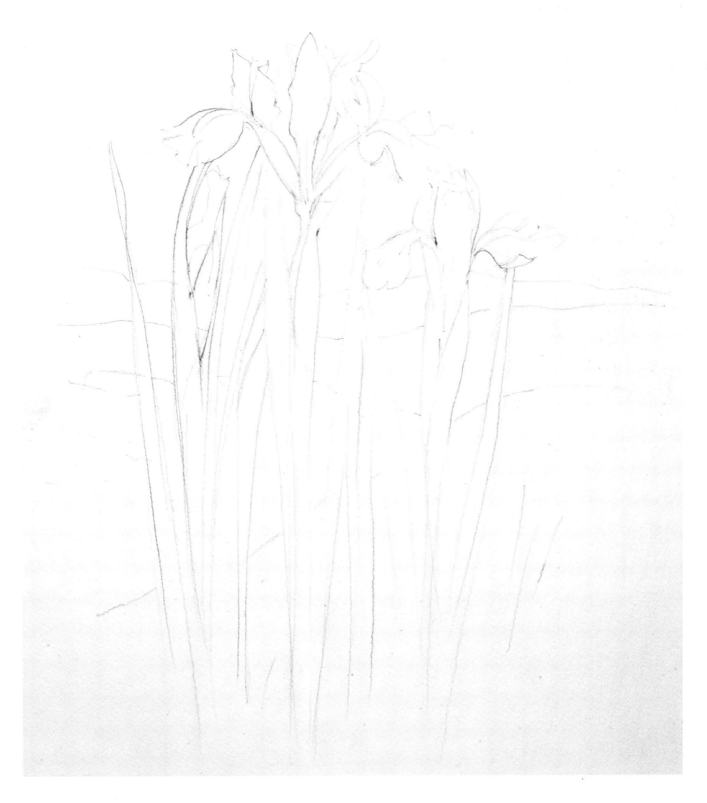

step 1

Use a No. 12 brush to apply a wash of Winsor violet that blocks in the petal areas across the composition and sets the light-to-mid-tones of the focal point. Leave the centres of the petals as negative spaces at this stage, and dilute and strengthen the mix as required to bring out the varied shades of the petals.

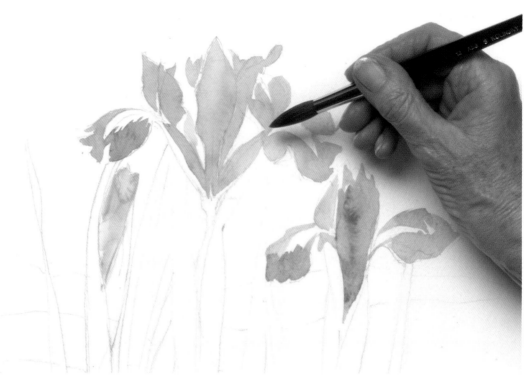

step 2

Dampen the paper in the sky area with clean water and a sponge. Mix a pale ultramarine wash and drop it onto the wet paper, spreading it over the sky area with the No. 12 round brush loaded with more clean water. Speed is of the essence here, so work quickly before the paper dries, and dampen it again if necessary.

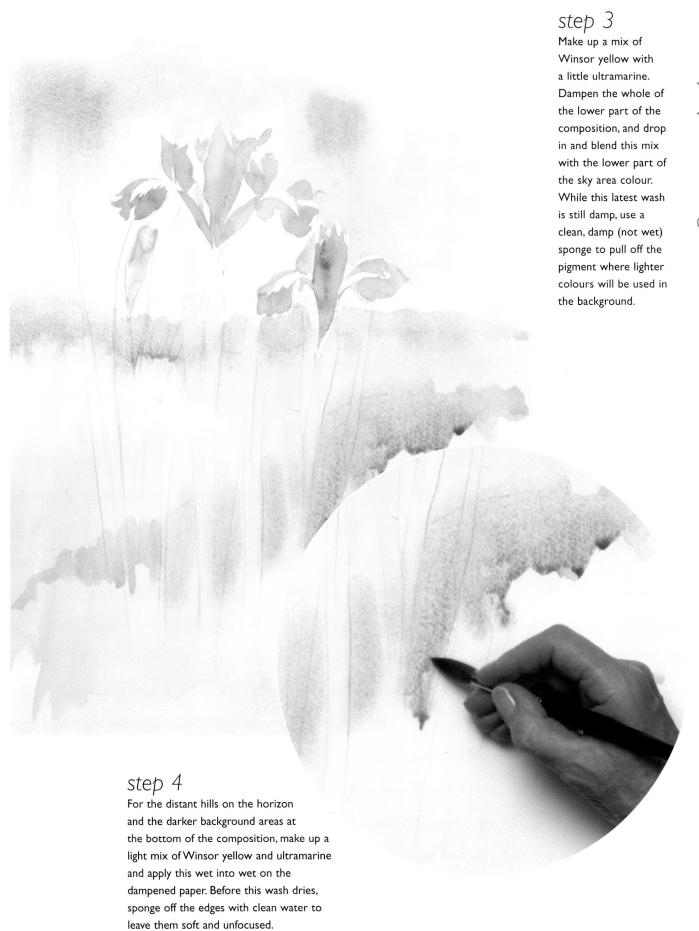

step 3

Make up a mix of Winsor yellow with a little ultramarine. Dampen the whole of the lower part of the composition, and drop in and blend this mix with the lower part of the sky area colour. While this latest wash is still damp, use a clean, damp (not wet) sponge to pull off the pigment where lighter colours will be used in the background.

step 4

For the distant hills on the horizon and the darker background areas at the bottom of the composition, make up a light mix of Winsor yellow and ultramarine and apply this wet into wet on the dampened paper. Before this wash dries, sponge off the edges with clean water to leave them soft and unfocused.

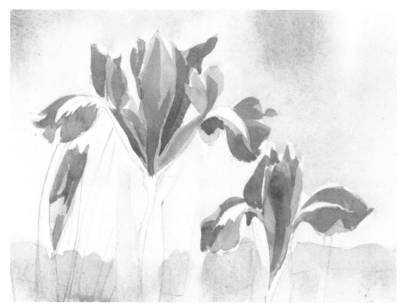

step 5

Make up a mix of ultramarine and Winsor violet, and use the No. 8 round brush to add the largest 'details' of the iris petals and thus strengthen the tone. Make sure to follow the contours of each petal accurately, and look closely at the variations of colour in each petal – some will have a more red-purple or blue tinge. Capturing these variations adds life to the painting. Again, leave the central parts of the petals as negative shapes for now.

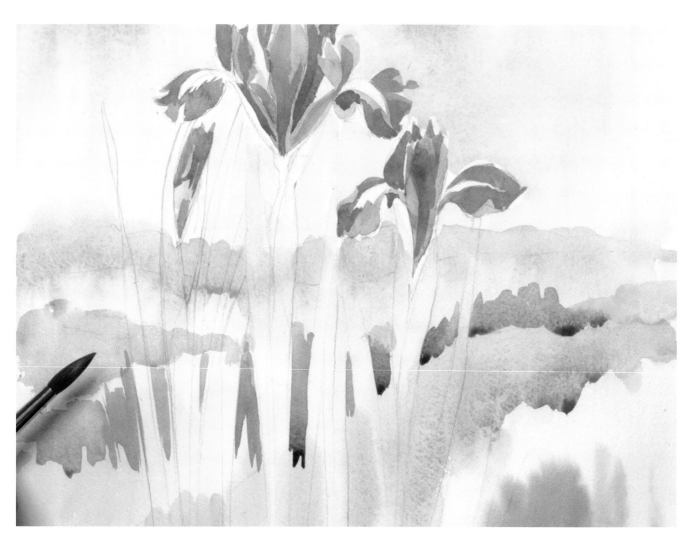

step 6

Mix Prussian blue and burnt sienna for the darker green areas of the background, dampen the areas you wish to paint, and apply the mix with the No. 12 brush, softening the edges as before. Don't forget to also darken the areas between the negative spaces of the iris leaves and stalks, but keep these also dampened and with soft edges for an out-of-focus background effect. Use a wash of Winsor yellow for the bright areas across the picture.

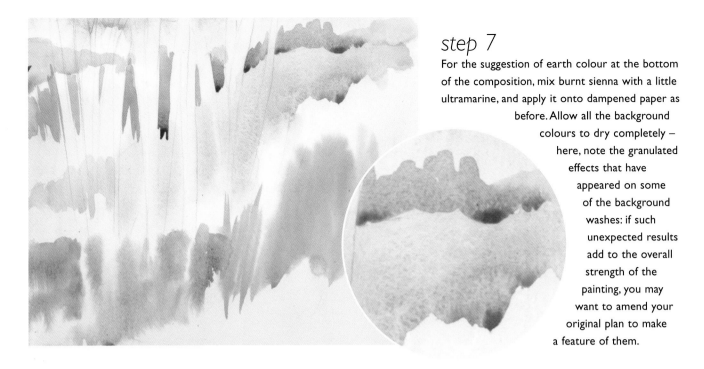

step 7

For the suggestion of earth colour at the bottom of the composition, mix burnt sienna with a little ultramarine, and apply it onto dampened paper as before. Allow all the background colours to dry completely – here, note the granulated effects that have appeared on some of the background washes: if such unexpected results add to the overall strength of the painting, you may want to amend your original plan to make a feature of them.

step 8

Mix ultramarine and Winsor yellow for the green of the iris stems, and apply the wash with long, solid strokes using the No. 12 round brush. The same mix can be used as a base for the leaves, but dilute and strengthen it as required to bring out the differences in tone and shadows. The colours will dry lighter than applied, so be prepared to add even stronger washes as you work.

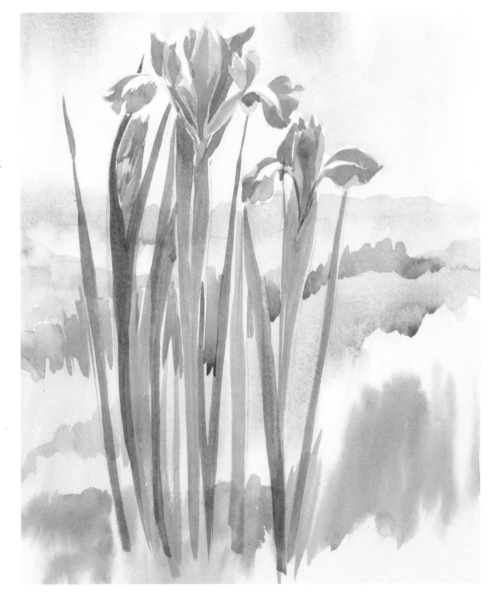

91

step 9

Make up a bright wash of Winsor yellow and yellow ochre for the centres of the irises, and apply this wash with the No. 8 round brush, leaving a tiny white line between the yellow and the purple. Then make a strong, deep mix of Winsor violet and ultramarine, and darken the rest of the petals, reinforcing the contour strokes and shadow areas.

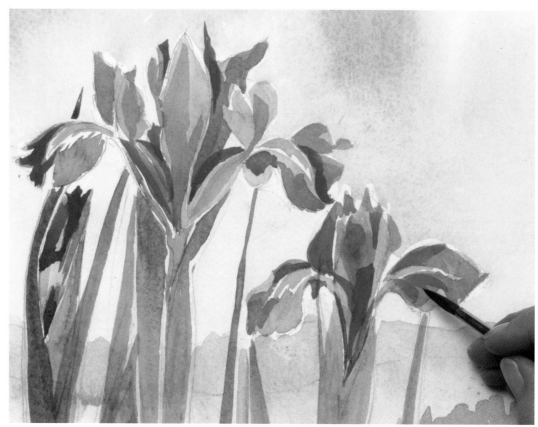

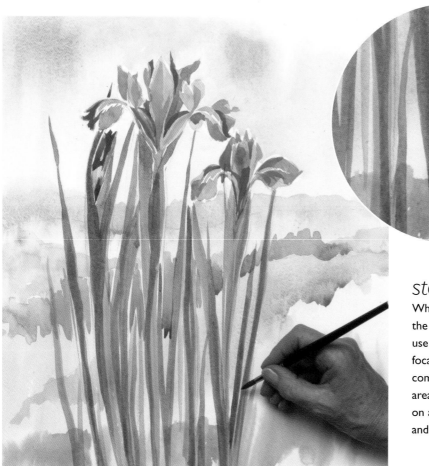

step 10

When the petals are dry, add a little ultramarine to the mix used for the stems and leaves in step 8, and use this to balance the new, darker tones. With the focal points completed, look across the whole composition, and enrich and darken the background areas as required. Be careful, however, not to keep on applying washes so that you lose the freshness and spontaneity of the painting.

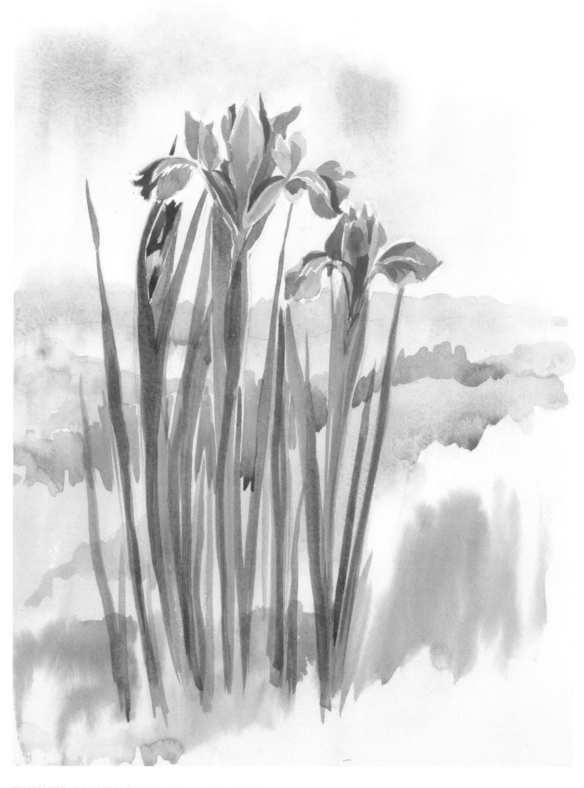

FINISHED PAINTING 430 x 305mm (17 x 12in)

The purple of the iris is lovely, and the background is different from anything we have tried before; I hope it will give you courage to go on and include more than just a flower in your paintings. Ideally, you should have the whole subject in front of you, but this isn't always possible – the flowers can be placed against a wall, by a ditch or a pond, or in a greenhouse. I keep all my references in a scrap book, and include colour samples and ideas from magazines in addition to my photographs; these references are invaluable, and help me time and time again.

project 5 · autumn ideas

Autumn can seem to be a quiet time after all the activity of the spring and summer, but more often than not it is a blaze of colours – rich reds, browns and ochres, in addition to most of the earth colours – and there are leaves, berries, seeds and nuts to paint. In the Sunday painting you will use a different eye level from the previous projects, maybe as low as ground level, to create a pattern of colour and texture; so collect your leaves and berries, add a windfall or two, and scatter them onto paper.

exercise 1: textures

As well as being creative, it is great fun finding ways to represent the different textures or patterns of flowers, whether soft or spiky, smooth or rough, speckled or striped. A brush has many uses – you can use it dry for a mottled effect, or wet to stipple, spatter or stencil. You can use the side of the bristles or spread them out in a fan or star shape. However, you can also use other materials to make marks – you can sprinkle salt, draw with a wax candle, or use a piece of card or a natural sponge – and don't throw away that old toothbrush!

SALT

step 1

This method gives an unpredictable, granulated texture. Apply one or more washes, and while they are still wet, sprinkle sea or rack salt onto the paint.

step 2

Allow the wash and salt to dry completely – this can take a few hours – then gently brush off the salt to reveal the textured marks.

SPATTERING

step 1

This simple technique is used here to suggest gorse bushes in flower. Paint a background wash and allow it to dry. Dip the bristles of an old toothbrush into a mix of a different or darker colour, then hold it horizontally over the paper and run your thumb or finger over the bristles to spatter the paint.

step 2

When the spattered paint is dry, add the branches and twigs in green with a brush, making sure you work with the direction of the spatters and do not go over them unnecessarily.

SPONGING

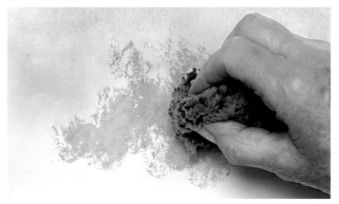

step 1

This is an effective and quick way to suggest clumps of leaves or berries. Apply a background wash and allow to dry, then pick up a different colour of paint on a natural sponge (manmade sponges have an even, uninteresting texture) and dab the required shape over the first wash.

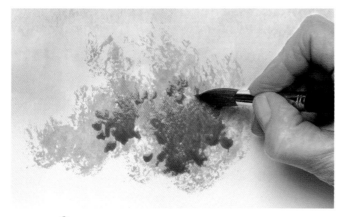

step 2

Add more sponge marks over the first ones for tonal variety, then reinforce the colours and shapes with a brush.

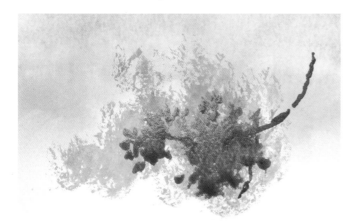

step 3

When the sponge marks are dry, use them as a base for adding details, such as a stalk, or other colours. Be careful not to overwork the subject, thereby losing the initial freshness of the sponging.

CANDLE RESIST AND CARD

step 1

This is a good technique for a loose texture – here, I have used it to paint a bush. With a clean wax candle, draw your required shape onto the paper; you may have to look at the paper from a low level to check your drawing.

step 2

Paint a wash around and over the waxed area, and allow this to dry. The wax will repel the paint, leading to a semi-negative shape.

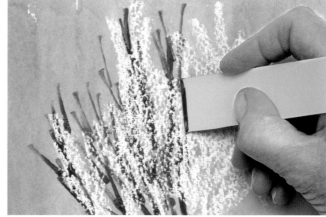

step 3

Cut a piece of thick card (mount card is ideal) about 25mm (1in) wide, dip the end into a strong dark mix of paint, and stamp it firmly onto the negative waxed area. Some of the paint will be resisted by the wax, giving a lively effect.

exercise 2: organizing nature

Confronted by nature in all its glory, it can be difficult to know where to begin. The word 'composition' seems to put the dread of failure into some people's hearts, but it is no more than finding a pleasing way of arranging your painting to its best advantage. Nature is often very helpful and does the job for you – particularly if you take the time to look at your subject from all available viewpoints – but there are other ways of helping the composition along: you can work with a particular colour scheme – such as warm or cool, you could base your painting on a single colour, or you could use complementary colours, for example. When working out what to include from a large view, a viewfinder is invaluable – either make one from card, or use your hands to make a rectangle and look through it like a camera.

USING A PHOTOGRAPH

If it is impossible to paint in front of your subject, you can always use a photograph. Mask off the area you want to concentrate on with masking tape, and paint from that. If you have access to a scanner or photocopier, you can use it to enlarge your chosen image.

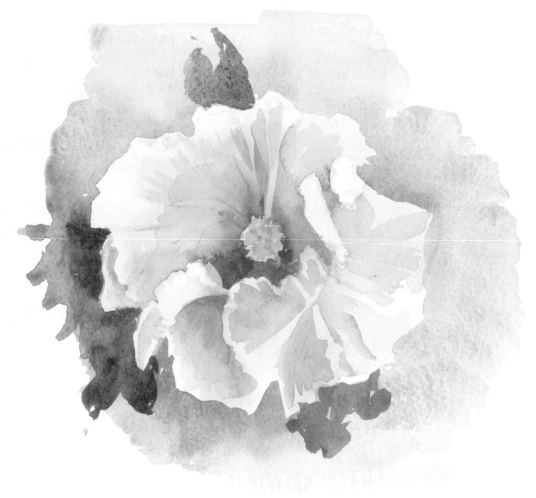

COMPLEMENTARY COLOURS

These sketches show how you can use complementary colours to achieve different effects, for instance the red of dahlias against a green background. If you have purple flowers, think about placing yellow somewhere in the composition; orange daisies look marvellous with a cool blue sky; and vibrant primary colours look bright and cheerful. This type of small rough sketch is always helpful in organizing your subject.

TIP

• *Try to be creative and to keep your eyes open; there are many sources of inspiration around you, from other artists' work to television images and magazine illustrations.* •

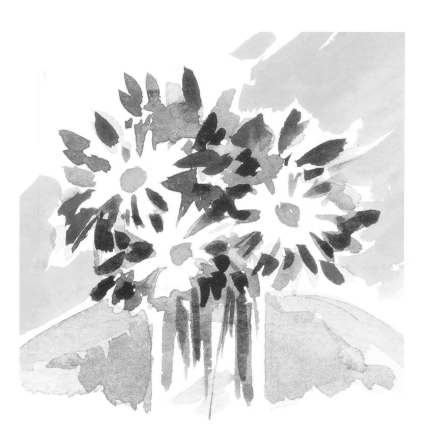

autumn flowers

For this painting I chose to work from part of a larger painting made from life. You may not always have the seasonal subject in front of you in real life, so use whatever you need – sketches, studies, reference photos and so on. Make sure you have a light source that is strong enough to cast shadows that will help to link the leaf shapes together; for right-handed artists, the light should come from the left, and vice versa. You should also practise painting leaf shapes and textures – on the ones here, there were quite a few splodges and marks in addition to the veins.

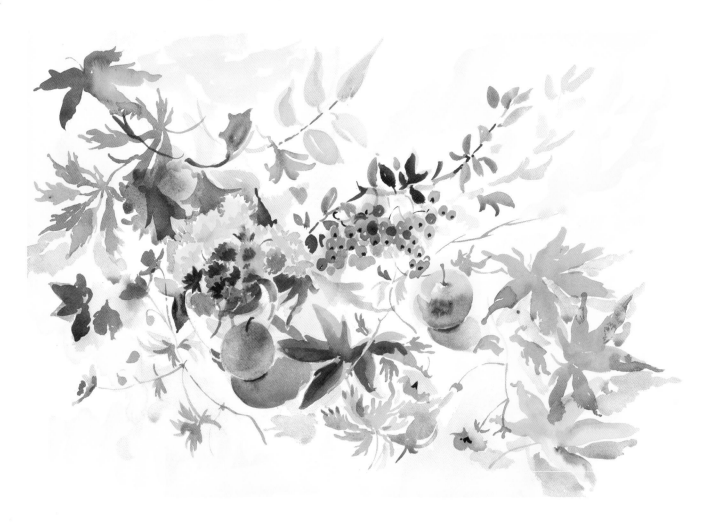

YOU WILL NEED

Colours

- brown madder

- burnt sienna

- cadmium red

- yellow ochre

- cadmium yellow

- ultramarine

- magenta

Paper and other equipment
- Bockingford NOT 300gsm (140lb)
- 2B pencil
- soft eraser
- sponge
- clean water
- tissue paper or kitchen paper

- eraser on end of pencil
- hairdryer (optional)

Brushes
- No. 12 round
- No. 6 round

EDITING

The original painting (*left*), although lively, was more a study of glorious autumn colours than a successful composition in its own right. I laid a piece of tracing paper over the area I chose for the Sunday painting, and carefully traced the relevant shapes, both positive and negative, onto it, using a 2B pencil.

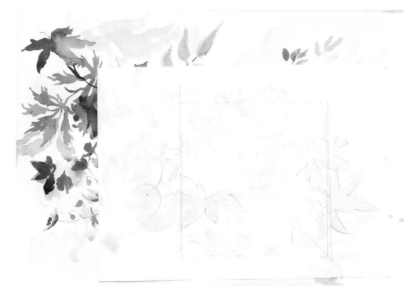

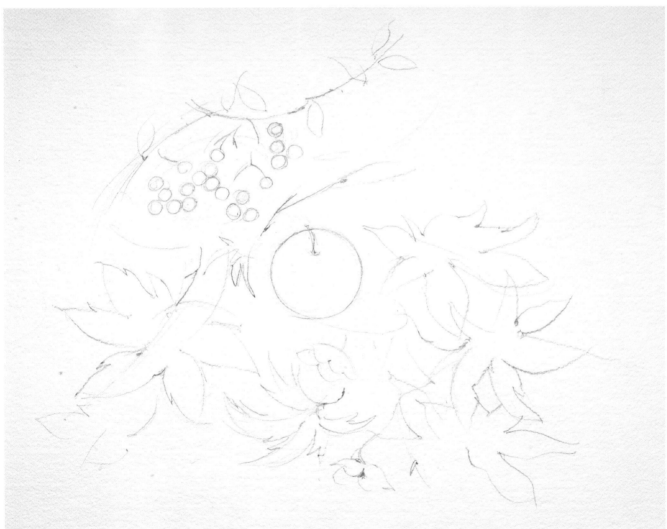

INITIAL DRAWING

With tracing paper, you have the choice of going over the pencil marks on the reverse side and then transferring the pencil onto your paper by drawing over the first marks again. However, it's quicker to use the tracing as a guide and draw the composition directly onto the watercolour paper with a 2B pencil. Start at the central focal point, here the apple, and then work outwards. If you wish, you can go over the 'boundaries' of the original tracing, but make sure you don't overcomplicate or clutter the drawing.

step 1

Use a clean sponge and water to dampen the outer areas of the composition, around the central fruits and leaves. While these are still wet, use a No. 12 brush to wash diluted brown madder to create a colour base at the top and left. Switch to a similar wash of yellow ochre for the lower and right-hand background areas. With a thicker but still diluted wash of yellow ochre, fill in the apple and the lower leaves, using the brush quite freely – don't worry if the paint goes beyond the pencil marks.

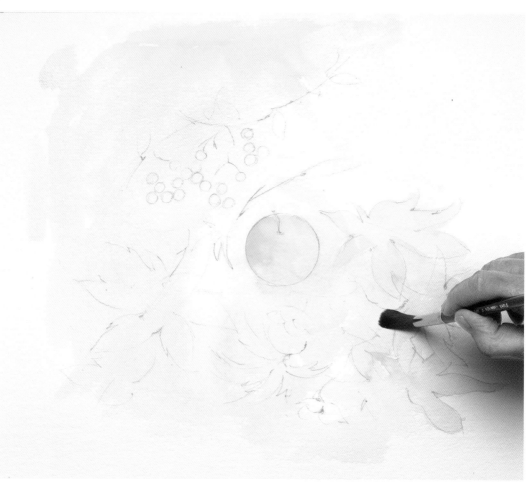

step 2

While the first washes are drying thoroughly – use a hairdryer to speed up the process, but be careful not to create runs and drips – make up a mix of the yellow ochre and brown madder. When everything is dry, paint the right-hand leaf, and use a little neat brown madder to darken it if required. Paint a stronger wash of yellow ochre on the apple, then apply the mixture, each time following the contours with the brush, and lastly add some pure brown madder, blotting the washes off with tissue paper to lighten them. For the area around the stalk, drop a very little diluted ultramarine onto the paper and allow it to spread. Allow the washes to dry.

step 3

Add ultramarine to the yellow ochre and brown madder mixture, and use this to establish the basic shape of the shadow of the apple. Apply a dilution of brown madder to the left-hand leaf, then add burnt sienna to this wash for the lower leaf on the right; try to keep the brushstrokes loose and free-flowing, which will add to the vitality of the finished painting.

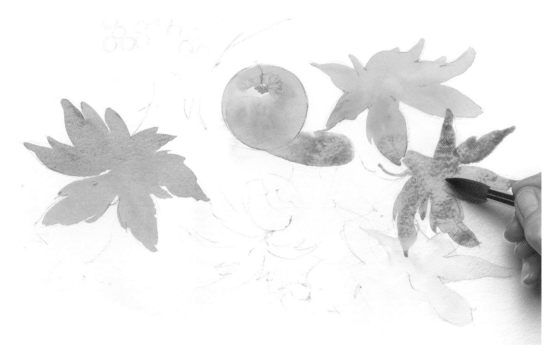

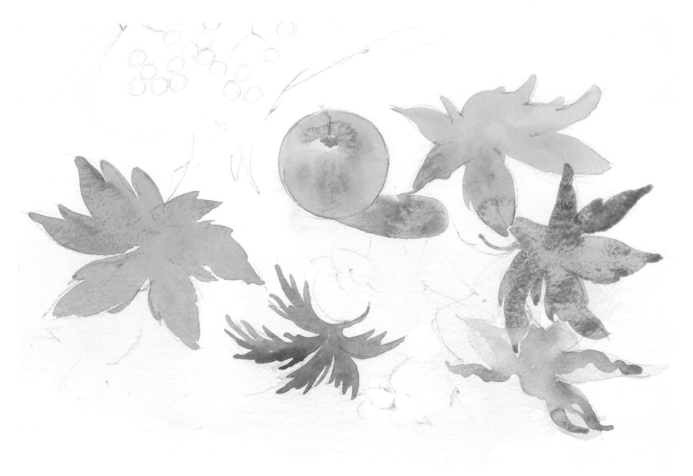

step 4

Use a mix of ultramarine and brown madder for the lower central leaf. Then dilute this with plenty of water for the lower right-hand leaf, and apply this quite wet onto the paper. Allow to dry completely, or use the hairdryer carefully – and remember that all colours dry lighter on the paper, so you are still establishing the shapes and colours at this stage.

step 5

Dilute brown madder and apply a light wash behind the berry shapes at top left of the composition, then mix and apply a stronger version of the same colour for the berry shapes themselves. The blobs of paint may run, so have a piece of tissue to hand to blot them. Use the same wash to fill in the last leaf shapes below and to the right of the apple.

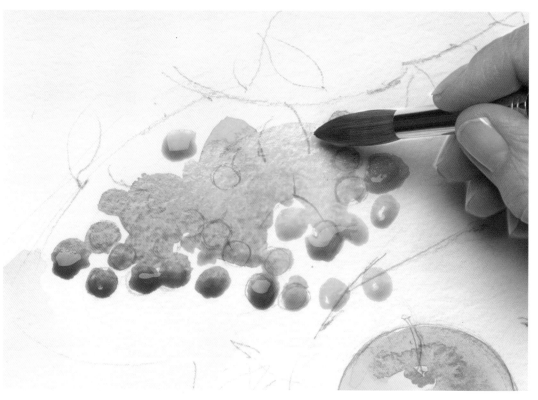

step 6

Make a dark mixture of green from ultramarine and cadmium yellow, and paint the small leaves at the top of the composition – use the shape and flexibility of the brush to form the individual leaf shapes. Note any variations in the green, and use different degrees of dilution of the mixture to delineate them. For the lighter leaves to the right of the apple, add cadmium yellow to the green mix.

step 7

Continue to paint the green leaves to the left of the apple, blending more ultramarine and cadmium yellow to the mix as required, and use the very tip of the brush to add the first stalks at the bottom and the left. As these darker colours dry, switch back to brown madder to strengthen the colour on the main left-hand leaf, this time following the contours of the veins. Use a pale wash of magenta for the pink flowers behind the apple.

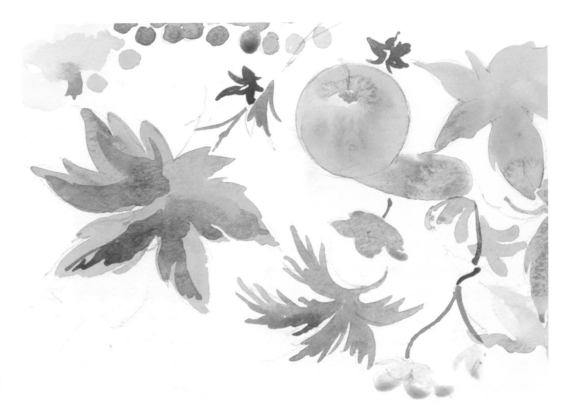

step 8

Mix ultramarine and burnt sienna for the stalks, and apply the wash with a No. 6 brush – if the rest of the painting is still not dry, turn it through 180 degrees for the stalks at the top, and then turn it back again for the lower ones between the berries and the apple. Use a mix of ultramarine and cadmium yellow for the leaves around the magenta, then use pure brown madder for the reddest details on the berry stalks and other red-brown ones. Allow to dry.

103

step 9

To stamp the berry shapes you need a small round eraser; the one on the end of a pencil would be suitable. For different colours you need different erasers, so use a variety of pencils and trim the eraser with a sharp craft knife if necessary. Dip the eraser into a strong mix of brown madder and practise on a piece of scrap paper before pressing the eraser firmly onto the watercolour paper.

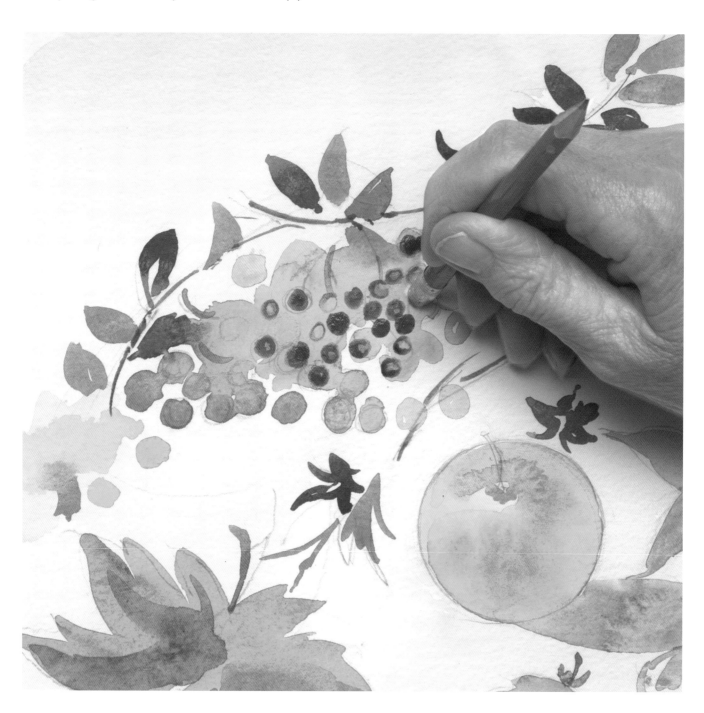

step 10

Make a warm mix of ultramarine and brown madder for the shadows, and use the No. 12 brush to apply light washes for the leaves and stalk of the top spray – you don't have to be exact, but try to follow the shapes as accurately as you can. Work down the left-hand side, adding shadows all the way down but being careful not to clutter the composition, then go across to the right-hand side. These shadows have hard edges, so you can let them dry without having to soften them by blotting.

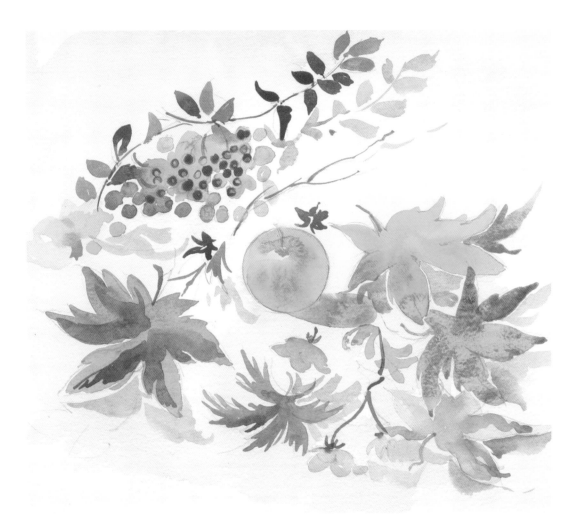

step 11

Using the No. 6 brush, strengthen the magenta of the pink flowers, and drop in a little ultramarine wet into wet for the shadows on the petals. With the No. 12 brush strengthen the yellow background washes with yellow ochre – make the brushstrokes on the right lively and directional, which will add to the vitality of the picture, and use small dabs of the brush to reinforce the left-hand side washes.

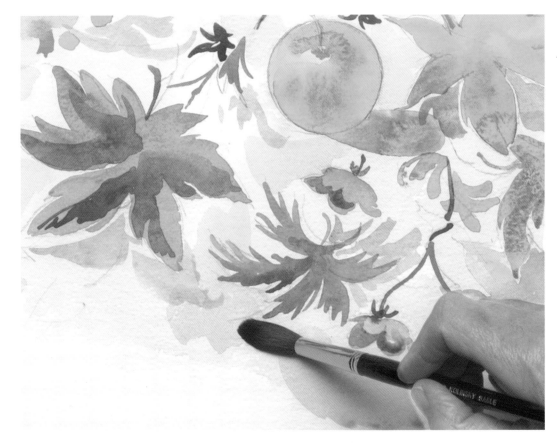

step 12

With most of the colours established and strengthened, go over the whole
painting to be sure that the colour and tonal balance is right. Dampen the apple
with clean water, then drop brown madder wet into wet to darken it; for more
variety of colour in the berries, use cadmium red and the pencil-end eraser.
Finish by using a pure ultramarine wash and the No. 6 brush to add the berry
ends and apple stalk.

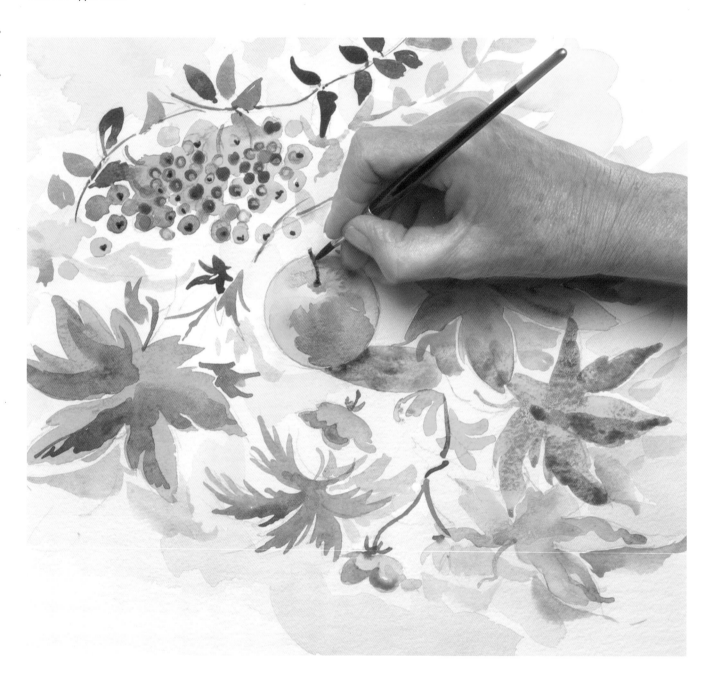

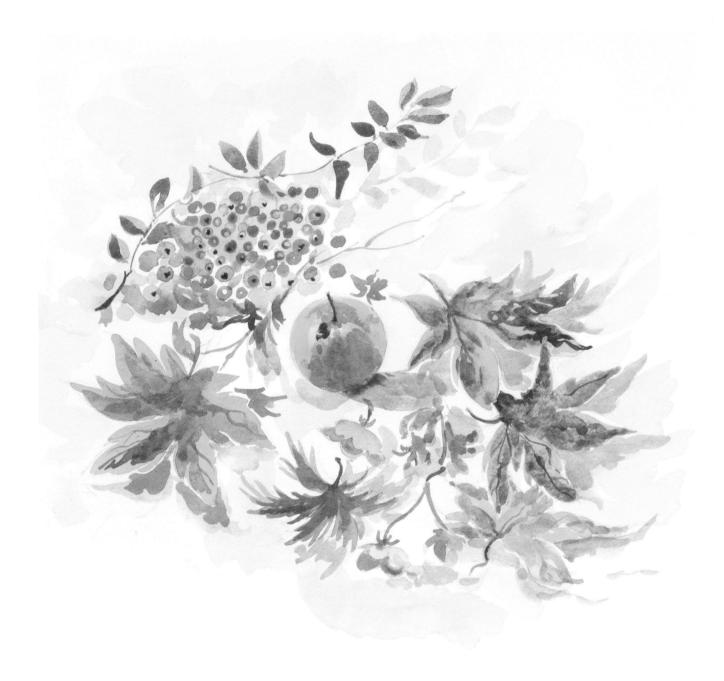

FINISHED PAINTING 350 x 460mm (13½ x 18in)

Painting these autumn leaves was like painting a pattern – I loved the reds and browns, and particularly enjoyed painting the background shadows to give a wind-driven feel to the composition. The apple was also fun to paint, and helped me decide to include more fruit and vegetables in future paintings. The low eye level used here is one that you could use in other situations; many artists consciously 'flatten' the picture plane to great advantage.

project 6 · wild flowers

After painting in a relatively formal way, it is good to splash out on something which is generally more free – you can use more colours, for a start. In my garden there are quite a few places where wild and garden flowers mix together happily. However, when painting, especially in watercolour, you should always have some sort of overall plan of work – mine is to start with the lightest colours and work up to the darks. Use pure colours to keep your painting fresh, and try to use your largest brush to keep the free, spontaneous feel.

exercise 1: deciding what's important

While you will be often most concerned with composing and organizing your paintings, the choice of what to leave out, if anything, is of equal importance; it can also be very difficult and thought-provoking, as including everything you see in the composition can be easier than exercising choice. For success, you must decide what is most important in your composition, and look at the overall components as a whole – you may choose to concentrate on colour, mood, sunshine or location, for example, and making these choices becomes less fraught with experience and an acquisition of techniques. Time is another factor to be considered – if you know you only have two hours to complete a painting, the fine details have to go. Sometimes standing at an easel can help you to distance yourself from too much detail.

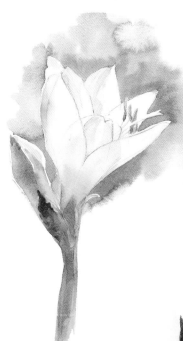

SINGLE FLOWER DETAILS

When painting a single flower you may want to include more detail, but the size and type of paper may also influence how you paint – and often you don't need detail to convey an impression of your subject. Detail is easier to produce on a HP (Hot-Pressed) paper than a Rough one; in the painting of an amaryllis a fair amount of detail has been included – the fact that it is a white flower seems to indicate that detail is more necessary than in the painting of the sunflower.

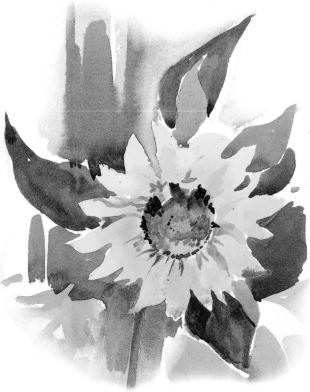

TIP

● If you feel that your painting is too 'tight', use a larger brush and paint further away from the paper. ●

DIFFERENT KINDS OF DETAIL

The pen and ink drawing of a poppy is quite detailed because of the nature of the medium and the proximity of the subject; in the next example the detail was added with coloured pencil, but in the third painting all detail has been excluded and edited out, to make a spontaneous and colourful painting that endeavoured to concentrate on sunlight and shadows.

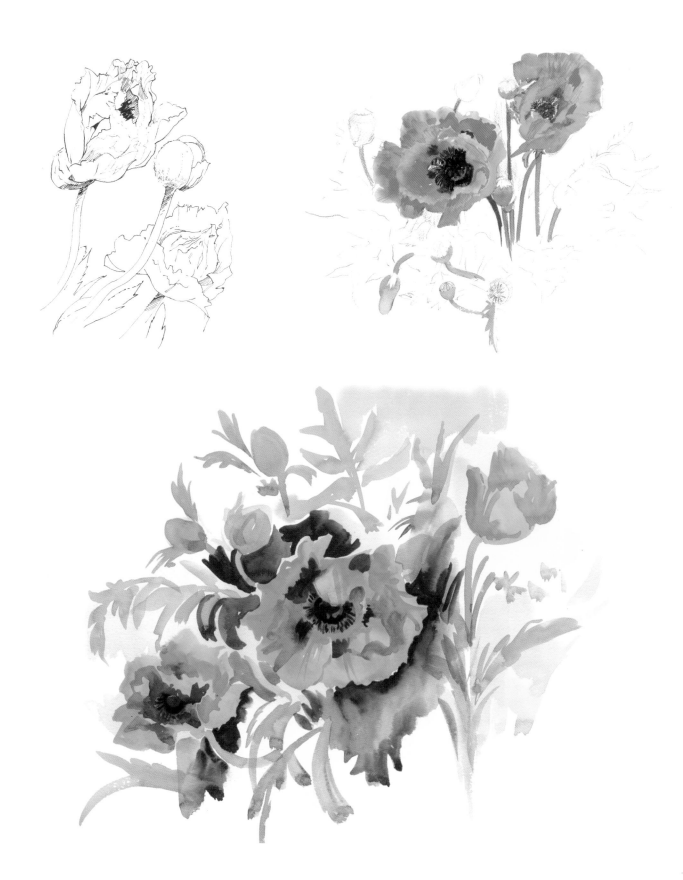

exercise 2: editing out detail

Choosing different viewpoints when painting flowers outside depends on various factors – the most important one is that you decide on a dominant flower or flowers and concentrate on this, letting the other parts of your view fade away. You may need to move several times before you make a decision, as a few centimetres can make a great deal of difference. Whether you sit or stand can play a part, too. Again, colour sketches are a great help, as is the use of a viewfinder.

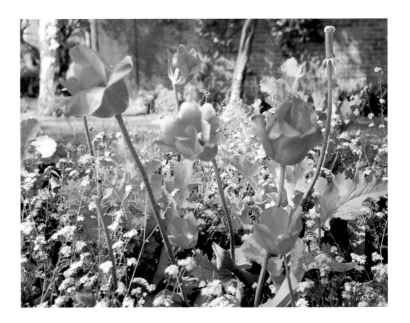

TIP

● *Look at your subject with half-closed eyes. This cuts out all the details and enables you to concentrate on the composition, tones and basic colours, and you can then choose how much or how little you wish to include.* ●

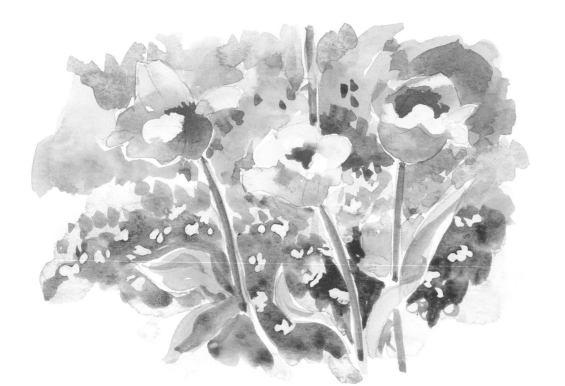

KEEPING WHAT YOU WANT

The photograph above shows a number of things that have been left out in the colour sketch – for example, the trees and the building behind, which are competing with the foreground tulips. Working with photographs can help when composing a painting and when you may be unable to get to the scene you wish to paint.

exercise 3: outdoor sketching

You can use your sketchbook in many ways, to record, explore and illustrate things that may be useful in the future. A sketchbook with watercolour is particularly useful when painting on location, as it is easier to carry around than separate sheets of paper; you can choose an upright or landscape format, or try a combination of both.

When sketching or painting outdoors, you need the right equipment (see page 14); make sure you haven't forgotten anything, as it is maddening to find you have left your brushes or a water bottle behind. I make a list and check off each item as I pack. You also need a lightweight board (your home one may be too heavy to carry for long), clips or tape for the paper, a stool and perhaps a folding easel. Try to travel lightly, reduce the weight where you can, and aim not to have to walk too far.

PENCIL SKETCH OF DAHLIAS

This is a way of getting to know the basic shapes of a particular flower or group of flowers before you paint.

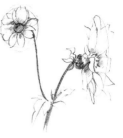

POTS ON PATIO

This is a pencil sketch of an idea for a painting, and will act as an *aide-mémoire*.

GARDEN VIEW

This line and wash sketch could be useful when composing a larger painting; I drew it first in pen and laid the washes after the ink was dry.

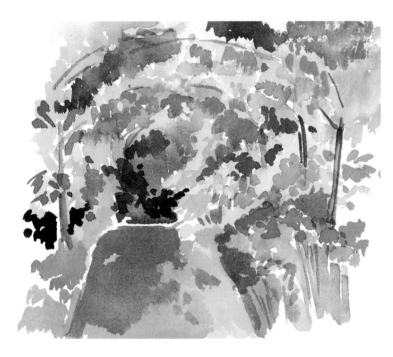

MONET-STYLE WALK

This watercolour sketch went into my sketchbook, as I had no time to make a larger painting.

CLEMATIS ON A COTTAGE

This is an example of using masking fluid for small white flowers. This sketch acts as a trial for a larger painting of the same subject.

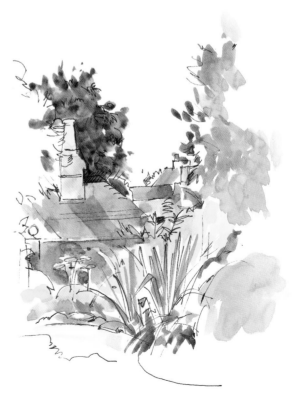

sunday painting

garden flowers

For this final Sunday painting, I decided to move away from the small palette of colours I have been using up to now; even with this expanded range, there are still a lot of mixes to be made. As with the autumn flowers in the last project (see page 100), the sketch from which this project is taken is very free and spontaneous, so you should not expect to achieve the exact same feel or composition in any subsequent versions – look upon the original as a basis for your own interpretation of the subject. In the original sketch (below) the background trees were too dominant, and I took them back to allow the white flowers to become more prominent.

YOU WILL NEED

Colours

- cobalt blue

- ultramarine

- cadmium red

- brown madder

- permanent rose

- burnt umber

- yellow ochre

- cadmium yellow

- white gouache (body colour)

- alizarin crimson

- burnt sienna

Paper and other equipment
- Bockingford NOT 300gsm (140lb)
- 2B pencil
- soft eraser
- sponge
- clean water
- hairdryer (optional)

Brushes
- No. 12 round
- No. 8 round
- No. 6 round

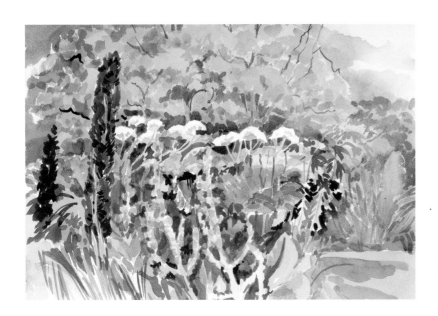

GARDEN IN SUSSEX

In this sketch I tried to achieve a feeling of distance with the trees in the background by making them lighter than the foreground. My basic palette of colours was extended with cobalt, a cool blue, plus opaque white gouache. I used these colours as a reference for the Sunday painting.

INITIAL DRAWING

Use a 2B pencil to lightly sketch in the very basic shapes. Even if you are not trying to make an exact copy of the reference sketch, still take the time to get the basic dimensions and relationships of the various flowers, including the negative shapes between them.

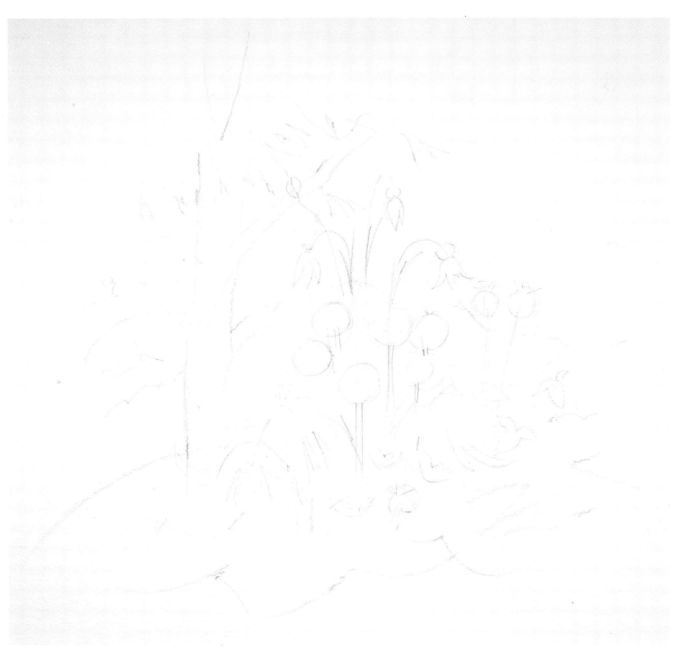

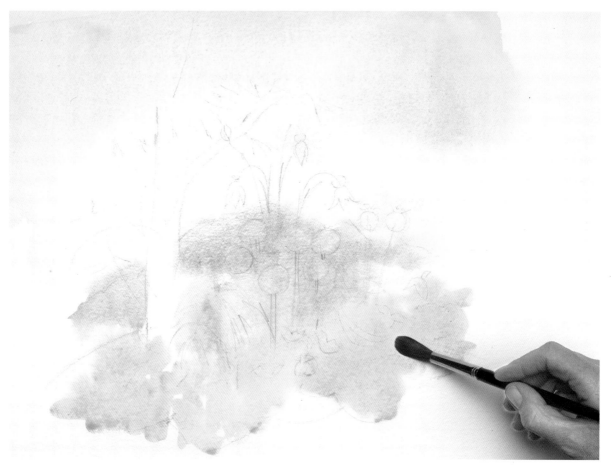

step 1

Use a clean sponge and water to dampen the top half of the paper. Apply a wash of cobalt blue across the sky area with a No. 12 round brush, then a wash of brown madder below. Follow this with an equally diluted wash of yellow ochre across the whole width of the composition, then a mix of alizarin crimson and ultramarine. Use permanent rose for the bright central poppy, then drop cadmium yellow into the ultramarine mix and apply it below the flower. Finish with a band of strong yellow ochre along the bottom, and allow all the washes to dry.

step 2

Because of the effects of perspective, the tone of the tree trunk appears grey. Mix ultramarine and burnt sienna to achieve this grey, and paint the trunk, branches and leaf shapes; while this is all still wet, drop a mix of cadmium yellow and ultramarine into the leaves to add a touch of green.

step 3

Add more leaves to the tree, then use the same green-grey mixes for the cow parsley to the left of the trunk; use cadmium yellow on its own for the underside. Make up a dark mix of ultramarine and alizarin crimson for the dark blue of the central flowers, and apply it using short dabs of the brush to suggest the irregular edges.

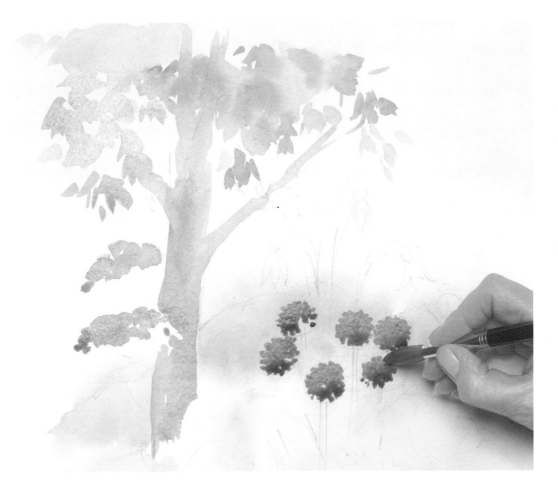

step 4

With the darker colours now in place, strengthen the poppy with a mix of cadmium red and permanent rose, looking to capture the shape and movement of each leaf in the brushstrokes. Let the whole painting dry, then add a mix of ultramarine and cadmium yellow for the leaves beside the poppy and below the blue. Work into the edges of the poppy leaves, and leave the negative shapes of the tall stems and yellow flowers.

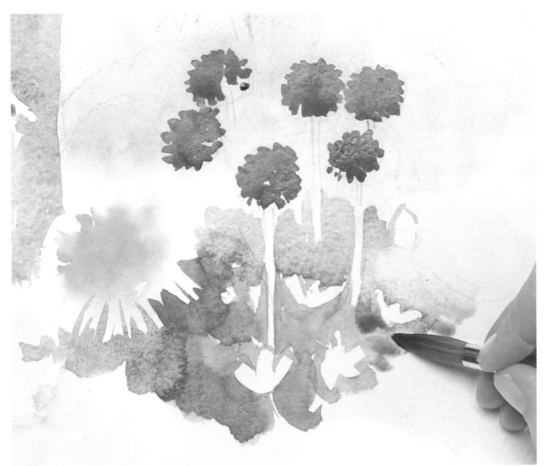

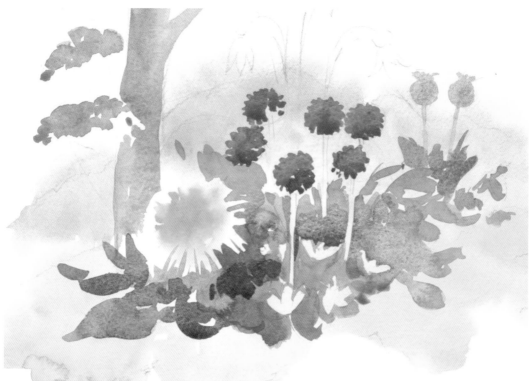

step 5

Use cadmium yellow to brighten the green of the lighter leaves on the right, noting the negative shapes. Use a strong mix of alizarin crimson and ultramarine for the darker areas on the lower left-hand side, and a diluted version of the same mix on the right. Use a No. 8 round brush and very light grey washes to establish the furthest flowers at upper right, then apply a little of the green mix to strengthen them.

step 6

Apply a wash of diluted alizarin crimson for the aquilegia at top centre, then switch to a No. 6 round brush and a dark version of the green mix for the stalks and leaves. If you wish, turn the paper through 180 degrees when working at the top of the composition, to avoid any chance of smudging the still-wet paint.

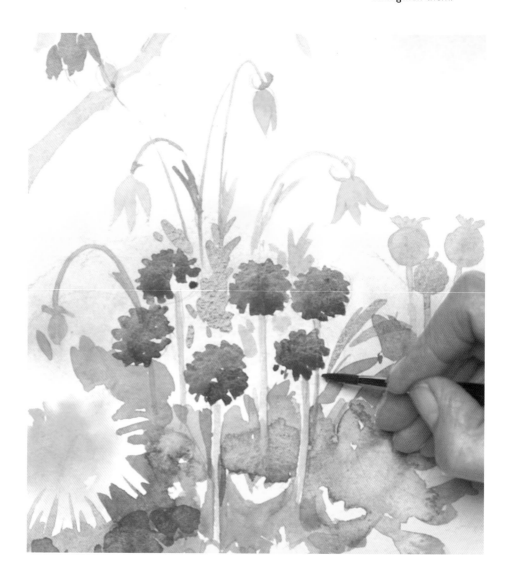

step 7

Use the dark green mix for the stalks of the cow parsley. Make up a mix of burnt umber and ultramarine, and apply this brown to create the shadows in the foreground and the dark shadows at the base of the tree. While this is still wet, add burnt sienna to the mid-point of the tree trunk, and at the very bottom of the picture to suggest earth. As these darkest colours are applied, look over the whole picture and strengthen any areas that are too pale, such as the yellow negative flowers among the green leaves.

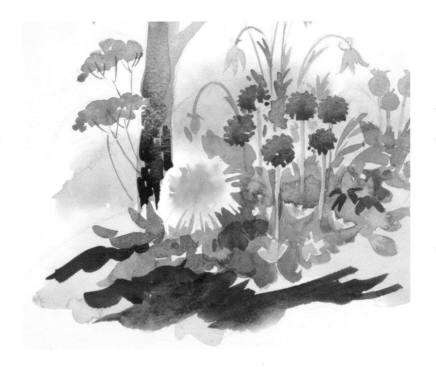

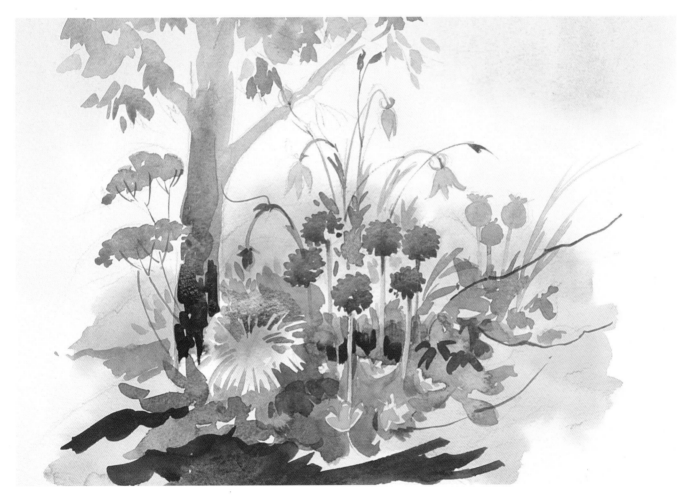

step 8

With the No. 6 round brush and the brown mix, add the twigs at far right, using long, free strokes, then use a larger brush and a diluted version of the same colour for the faraway shapes on the left. Add green for the buds above the central aquilegia, and use this colour to strengthen any stems and stalks that appear too light. Dilute the grey mix and use this to soften the effect of the central red poppy.

117

step 9

Allow the painting to dry completely, using a hairdryer carefully if you wish. The background washes were applied freely across the paper, so you cannot use negative shapes for the tiny white daisies. Instead, clean the No. 6 round brush and use a little white gouache (body colour), dabbing a few simple marks to depict each leaf and flower. Be careful about mixing gouache with watercolour paints, as it can dirty them – the answer is to use a separate palette.

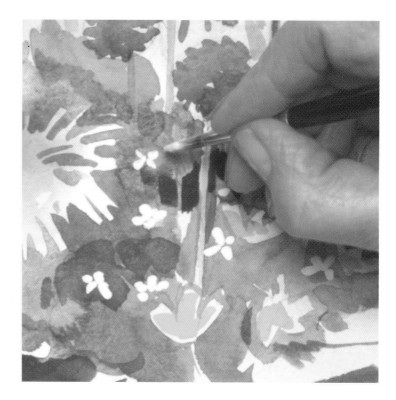

step 10

For the finishing touches, you may want to further strengthen the green of the leaves using a slightly darker green mix; use the shape of the No. 6 round brush to make each leaf shape. To show the variety of colours in the tree trunk, drop in diluted washes of yellows and greens, allowing them to flow into each other; keep the colours muted and subtle, and blot out any overstrong ones.

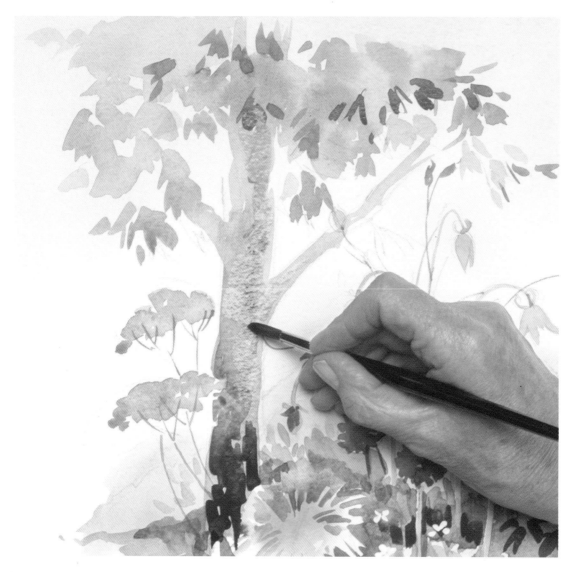

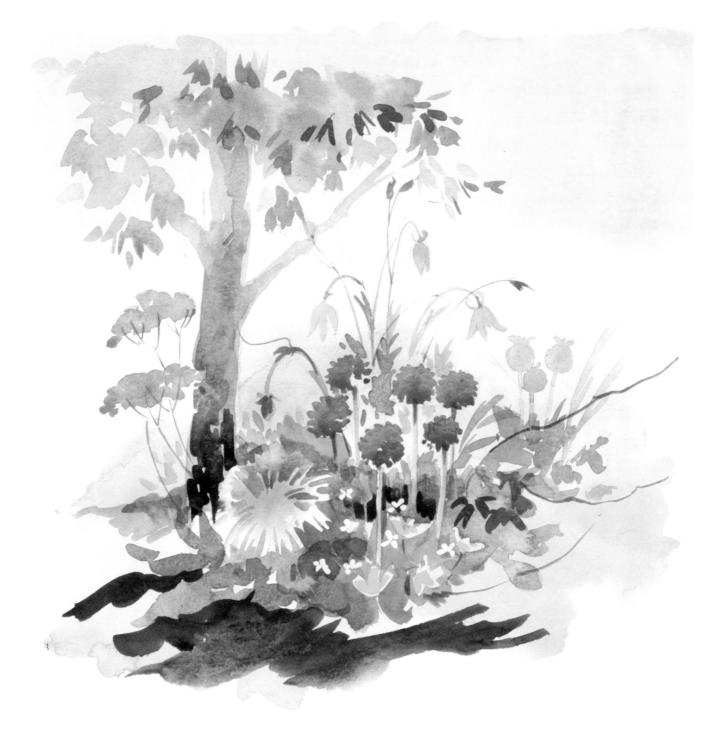

FINISHED PAINTING 355 × 300mm (14 × 12in)

I hope that this final Sunday painting will give you the confidence to go out and try it for yourself. It can be a bit daunting to be faced by your own ideas and be told to splash out on something free, but if you work in an organized way you should be all right; if the paint runs or the wet into wet doesn't work, it doesn't really matter – you have to learn to turn it to your advantage and enjoy controlling your painting. By making a number of small studies you can learn how to subtract the non-essentials – in fact, working in a small size prevents you from including too much detail in the first place. It is preferable to paint in front of the subject if you can, but sketches and studies can help when you have to work indoors, as you can select and discard the non-useful elements.

Good luck with your painting!

119

index

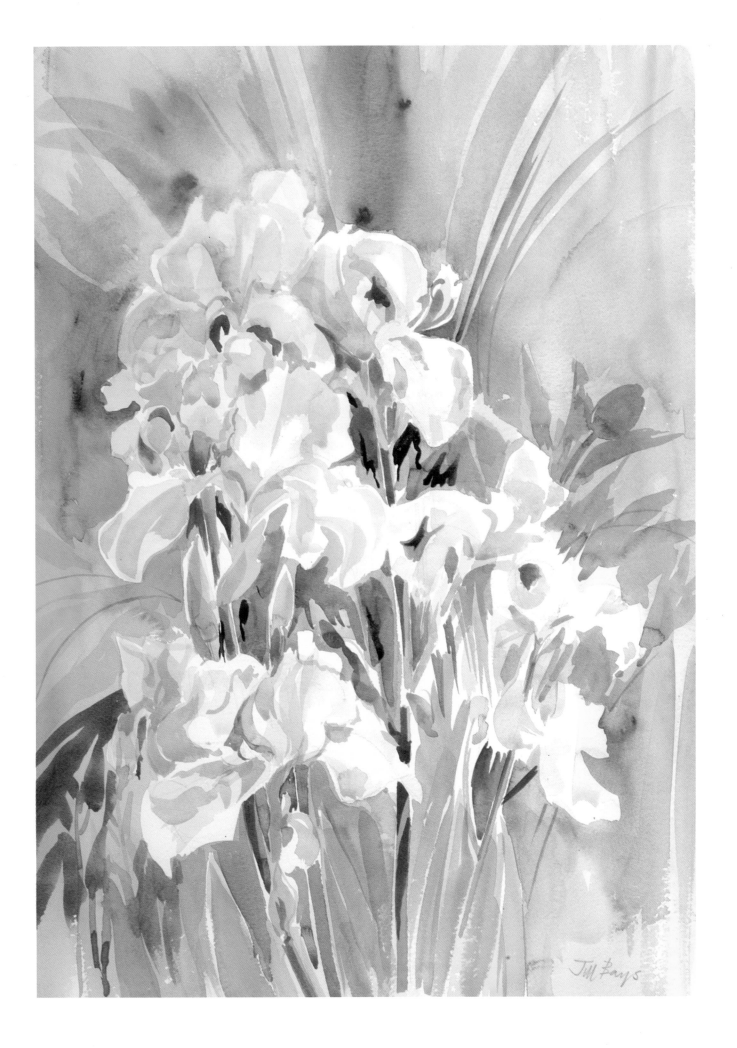

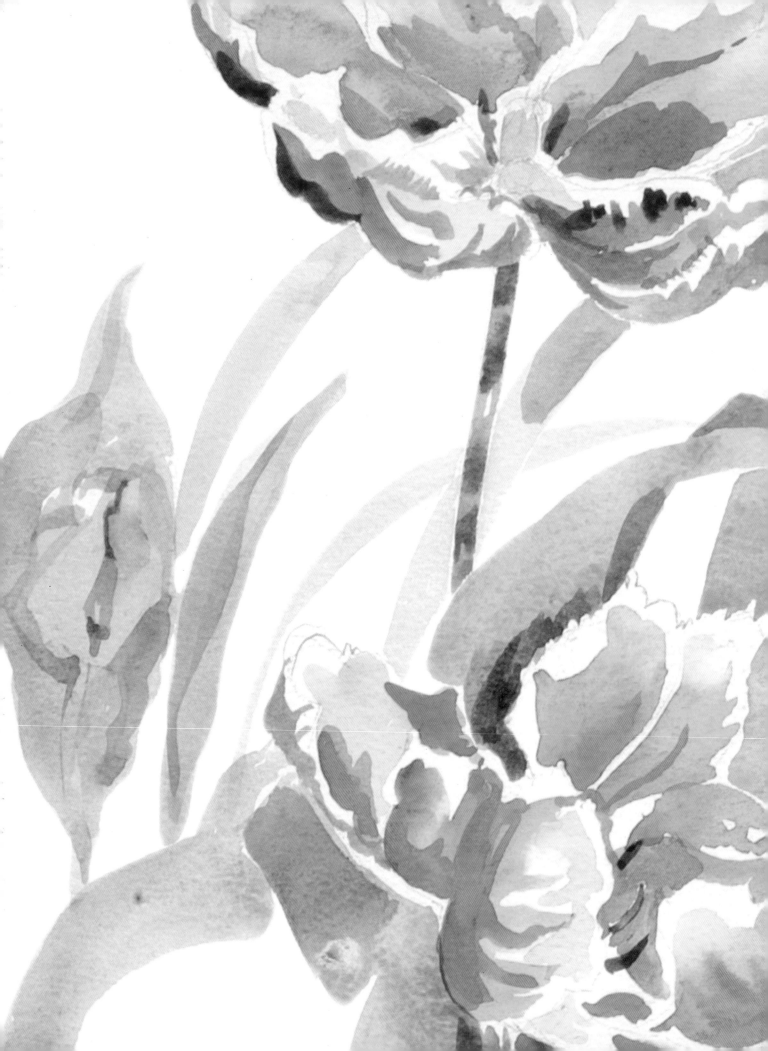